interesting fist

CW00549860

glitter books

INTERCEPTING FIST:
THE FILMS OF BRUCE LEE
and the golden age of martial arts cinema

Jack Hunter

ISBN 1 902588 013 4

Published 2005 by

THE GLITTERBOOKS OF LONDON

contents

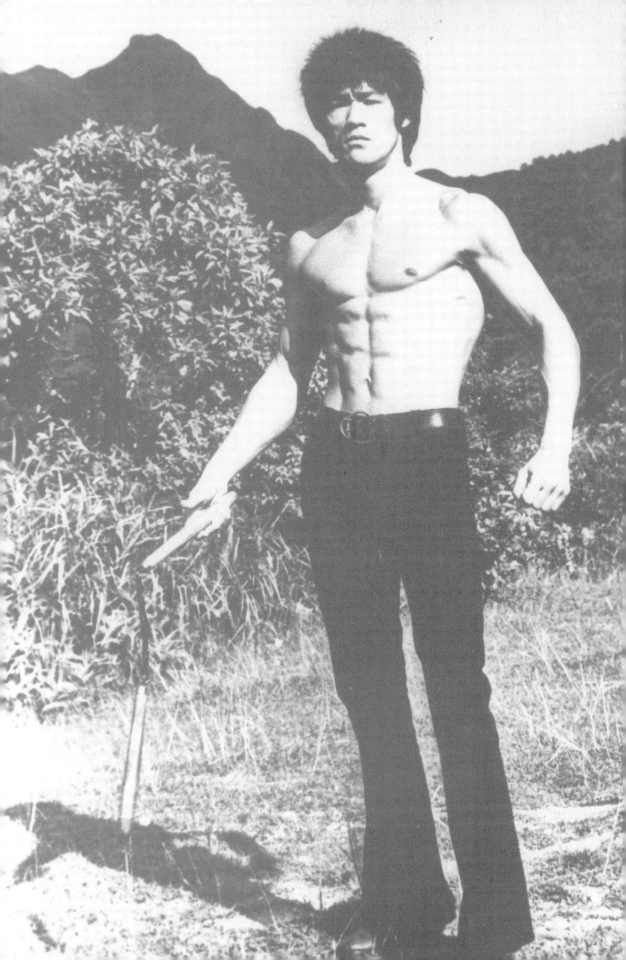

preface
dragon & snake

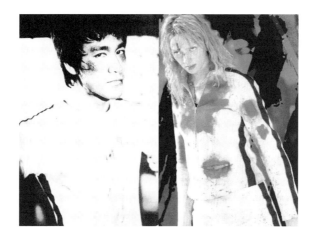

"If Bruce Lee were alive, he'd be in *Kill Bill*" —Quentin Tarantino

The "Golden Age" of Hong Kong kung-fu cinema, of which Bruce Lee was the global face, flourished in the early to mid 1970s and started to fade away – at least in terms of cool – with the release of **Drunken Master** (1978) and the rise of smiley kung-fu clown Jackie Chan. The recent release of Quentin Tarantino's **Kill Bill**, a tribute to the Shaw Brothers who produced the majority of kung-fu classics, has provoked fresh interest in the pre-Chan films (and their Japanese counterparts)[1]. Tarantino's decision to costume Uma Thurman (playing the Bride) in a yellow, black-striped jumpsuit like Bruce Lee's in **Game Of Death** is just the most obvious in a plethora of references to the Golden Age throughout the film. The other biggest connection is the casting of Gordon Liu, star of kung-fu epics like **5 Masters Of Death** (1974), **Master Killer** (1978) and **8-Diagram Pole Fighter** (1983). Liu has two roles in **Kill Bill**, the second being that of Pai Mei, the martial arts master who fight-trains the Bride for revenge – a nod to one of the staple plot pivots of the vintage kung-fu flick. The character of Pai Mei comes from various films, including **Shaolin Executioner** (1977) and **Fists Of The White Lotus** (1980). Other films referenced by Tarantino include Jimmy Wang Yu's **Chinese Boxer** (1969) and **Master Of The Flying Guillotine** (1975). **Chinese Boxer** was not only the first full-on open-handed combat movie (as opposed to *wu xia* or swordfight movie) in China, but also the first where one lone fighter takes on "100" opponents and wins – the blueprint for **Kill Bill**'s "Showdown In The House Of Blue Leaves". Bodyguard Go Go Yubari's spiked ball and chain in the same sequence is reminiscent of the "flying guillotine" in **Master Of The Flying Guillotine**, and Tarantino also uses music from that film (*Super 16* by Neu). Another musical

reference is Quincey Jones's *Ironside Theme*, which was earlier used in **Five Fingers Of Death** (1972), in the same way as Tarantino does (accompanied by the screen glowing red). **Five Deadly Venoms** (1978) contains the reptilian gang blueprint for Tarantino's Deadly Viper Assassination Squad. All that remains for film fans is to track down the original movies, and with most of them now being released on DVD, the time is right for reappraisal. And even after 30 years, the name of Bruce Lee is still the first that comes to mind when the "Golden Age" of kung-fu is mentioned. *Intercepting Fist* is a document of Lee and many of these movies, their stars, and directors.

–Candice Black, 2004

1. Japanese films referenced by Tarantino in **Kill Bill** (to degrees ranging from blatant to infinitesimally subtle) include: **War Of The Gargantuas** (1966); **Black Lizard** (1968); **Goke, Bodysnatcher From Hell** (1968); **Lady Snowblood** (Toshiya Fujita, 1973); **S**hogun Assassin** (1972); **Hanzo The Blade** (1973–74); **Battle Royale** (2000); and **Ichi The Killer** (2001). His use of the iconic Sonny Chiba is also key; Chiba played Hattori Hanzo in the *Hattori Hanzô: Kage no Gundan* TV series (1980), and was the star of the brutal **Streetfighter** movies (1974), and also **Golgo 13** (1973) amongst others. Most of these these films and many more are covered in Jack Hunter's study *Eros In Hell: Sex, Blood And Madness In Japanese Cinema* (Creation Books, 1998).

part one

the golden age

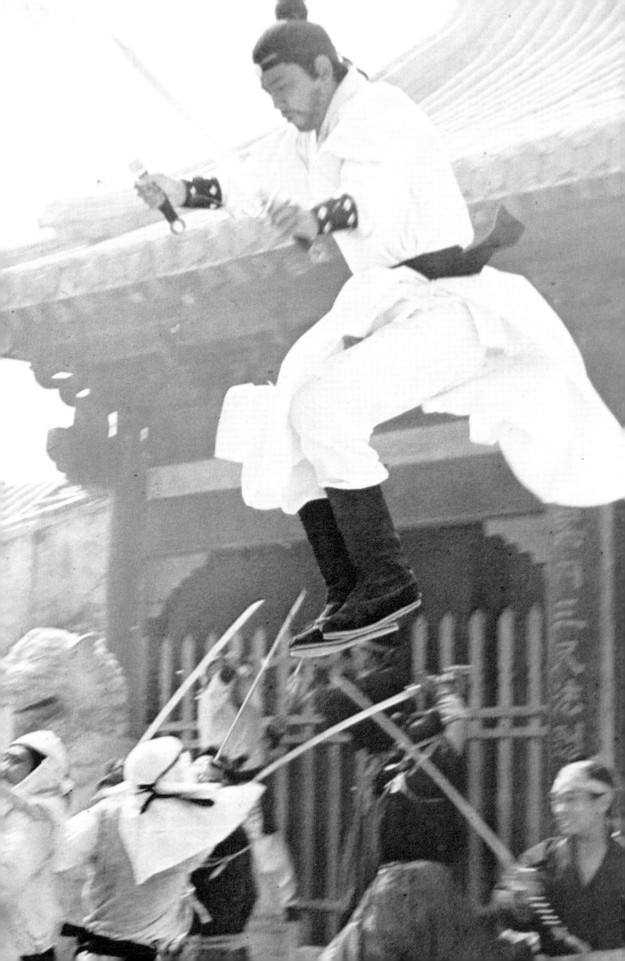

The first Hong Kong production company was established in 1921, and over the following decades two strains of cinema emerged – Mandarin (20%), and Cantonese-language (80%). Dictated by censorship and simple tastes, typical Hong Kong product was moralistic, sentimental, conservative and politically anodyne, and formulated into stock genres. Hong Kong really began to flourish when the Sino-Japanese war erupted and Shanghai – formerly the Hollywood of the East – was occupied by the Japanese in 1937[1]. Amongst the influx of migrant/refugee Chinese companies was Tianyi, a major Shanghai studio, which was managed by Run Run Shaw, one of the infamous Shaw brothers. By the early 1960s the Shaws had merged their resources and successfully eclipsed their nearest rival, MP & GI. Moving from Kowloon to Clearwater Bay, they completed work on their celebrated Movietown studio in 1961, with the aim of producing around 50 good quality films a year. The Shaws also owned a vast circuit of cinemas throughout non-Communist Asia, via which they distributed both their own, and imported, films. Directors such as Li Han-hsiang, with historical/operatic epics like **Liang Shan-po yü Chu Ying-t'ai** (**Eternal Love**, 1963), helped establish the Shaws' reputation. But it was with the resurgence of the martial arts genre that they really came into their own.

The martial arts genre dates back as far as the **Huoshao honglian si** (**Burning Of The Red Lotus Monastery**) series of the early 1930s, and was fully realised by the later, more authentic **Huang Fei-hung** series which commenced in 1949. When Mandarin cinema briefly gained ascendency in the late 1950s/early 1960s, martial arts movies fell away until Chang Cheh's **Hao-hsia chien ch'ou** (**Tiger Boy**) started a Cantonese revitalisation in 1964. It was in 1966/67, with King Hu's **Ta tsui hsia** (**Come Drink With Me**) and **Lung-men k'o-chan** (**Dragon Gate Inn**), that the martial arts genre (*wu-hsia p'ien*) was fully resurrected for consumption by modern audiences. King Hu pursued his own Taoist/metaphysical vision of martial arts with the seminal, 3-hour **Hsia nü** (**A Touch Of Zen**, 1969), a startling blend of ghost story, love story, swordplay, and metaphysical/zen elements, evoking a feudal universe of sword-wielding heroines, haunted temples and hermaphrodite monks who bleed liquid gold. Hu's later films include **Ying-ch'un-ko-chih feng-po** (**The Fate Of Lee Khan**, 1973), **Chung-lieh t'u** (**The Valiant Ones**, 1974), and **Shan-chung ch'uan-ch'i** (**Legend Of The Mountain**, 1979). Hu's mantle was taken up by directors such as Tsui Hark, with his outrageous epic **Zu Warriors From Magic Mountain** (1983), and Ching Siu Tung, creator of the Hark-produced **Chinese Ghost Story** (1979) and the later, eyeball-exhilarating **Swordsman** trilogy.

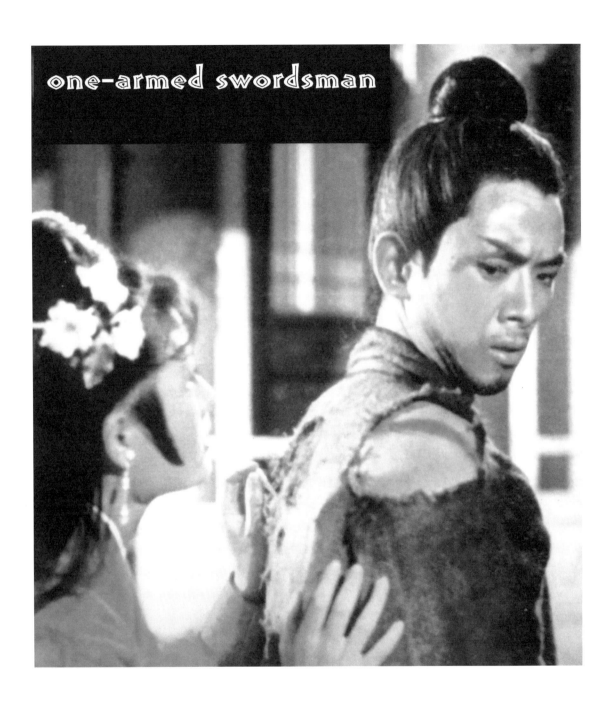

one-armed swordsman

Meanwhile other innovative directors, including Chang Cheh and the less celebrated Griffin Yueh Feng, were producing works of equal individualism. In such films as **Tu-pi tao** (**The One-Armed Swordsman**, 1967) and **Chin yen-tzu** (**Golden Swallow** aka **The Girl With The Thunderbolt Kick**, 1968), Chang Cheh conjures a cruel universe of revenge, mutilation and bloody death. This new realistic approach to screen violence was matched by Yueh Feng in his classic **Duo hun ling** (**The Bells Of Death**, 1968), a revenge story which features a fast-moving succession of blood-spattered action set-pieces. But Feng, whose other Shaw Brothers films include **Dao jian** (**Rape Of The Sword**, 1967) and

Wu lin feng yung (**A Taste Of Cold Steel**, 1970), never achieved the acclaim afforded to Chang Cheh, whose aforementioned **One-Armed Swordsman** came as a shattering stylistic breakthrough on its release. Although the film occasionally gets bogged down with a romantic sub-plot, **One-Armed Swordsman** marked a trend away from the predominant focus on women in the cinema of the time, and towards the male world of martial arts, chivalry and honour. Even more striking was Chang Cheh's portrayal of violence; for the first time, copious amounts of stage blood were used in fight scenes, spurting out as limbs were severed and bodies punctured in brutal and graphic detail.

Wang Yu plays Fang, the film's eponymous hero, a martial arts expert who, after his sword arm is hacked off by a surprise attack, manages to rehabilitate himself and re-train using his left arm. With these new-found and improved skills, he is able to defend his master against the forces of evil, led by the sinister Long-Armed Devil, whom he defeats in the film's climactic battle. Along the way there are multiple bloody killings and maimings on both sides, with the film's moral focus being on inviolable warrior codes of honour and vengeance. **One-Armed Swordsman** quickly became the first ever million-dollar grossing Hong Kong movie. This would be the format of Chang Cheh's films to come, with escalating levels of bloodshed and less and less participation of females.

After **One-Armed Swordsman**, Chang Cheh and Wang Yu worked together on **Da ci ke** (**The Assassin**, 1967) and the superior **Hsia yu-yen** (**Golden Swallow** aka **Girl With The Thunderbolt Kick**, 1968). In the latter film Yu plays Silver Roc, an enigmatic killer capable of butchering a dozen foes with one sweep of his blade. Silver Roc's climactic showdown with the Dragon Gang remains one of the most epic sword battles of the genre, as Chang Cheh takes the nihilistic formula of his previous hits to new extremes. The other male lead was taken by Lo Lieh, another martial arts star who would later figure in many of the genre's classic films, while the title role of Golden Swallow went to Cheng Pei Pei, first female superstar of the new martial arts cinema, who had risen to fame in King Hu's **Come Drink With Me** (where she also played Golden Swallow).

Golden Swallow

Come Drink With Me

Over the next four years Cheng Pei Pei's films would include **Lady Hermit** (1968/9, alongside the then 16-year-old Shih Szu, female star of the future); the atmospheric **Dragon Swamp** (1969); Ho Menga's **Lady Of Steel** (1970); **The Shadow Whip** (1971, in which she wields a whip in snow-covered

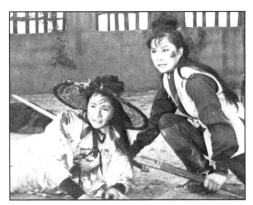
Cheng Pei Pei, Shih Szu; **Lady Hermit**

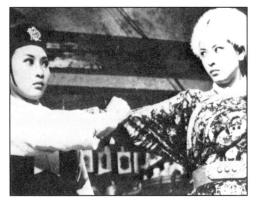
Angela Mao, Hsu Feng; **The Fate Of Lee Khan**

landscapes to great effect); and Lo Wei's **Lady Kung-Fu** (1973, a "female" version of the director's earlier **Fists Of Fury**) before taking an extended break from acting. Other female stars of the time included Hsu Feng (**A Touch Of Zen, Invincible Sword**, 1971; **The Fate Of Lee Khan**) and Li Ching (**Twin Blades Of Doom**, 1969; **Vengeance Of A Snow Girl**, 1971).

Chang Cheh and Wang Yu went on to collaborate on a sequel to their earlier success; **Return Of The One-Armed Swordsman** (1969) delivered more of the same, with maimed swordsman Fang being forced to take up arms again when his wife is threatened by the notorious Eight Demon Swordsmen. The mutilation motif is extended as the evil gang capture all the local sword-clan leaders and demand an arm from each clansman as ransom. One by one Fang defeats the Eight Demon Swordsmen in an orgy of vengeful slaughter, and the film ends with hundreds of maimed corpses as the forces of good and evil clash in an epic battle that climaxes with the Demon leader, Furtive King, being hacked to a thousand pieces. Rare for a sequel, **Return...** actually betters the original both in terms of pacing and in the action. The fighting comes fast, furious and relentless, even more bloody than before, and the wicked array of secret weapons employed by the Demon clan (who boast names like Ape's Arms and Hell's Buddha) sets an imaginative trend for years to come.

Wang Yu would part company with Chang Cheh and the Shaws in 1970 to set up his own production facility in association with Golden Harvest. But before he did, he initiated his own version of martial arts cinema with the self-scripted and -directed **Lung-hu tou** (**Chinese Boxer** aka **Hammer Of Gods**, 1970). Featuring an unprecedented approach to unarmed fighting (as opposed to swordplay) as the ultimate all-conquering art form, **Chinese Boxer** and the films that followed opened the way for the cataclysmic advent of Bruce Lee in 1971's **The Big Boss**. The short but incandescent era of the kung-fu film had arrived.

Chinese Boxer is set in a small town where a trouble-maker, dismissed from his local fight-school, returns to wreak revenge. Accompanied by three deadly Japanese karate-killers, he picks fights with members of the school (one is bloodily dispatched in a restaurant by a double eyeball-gouge) before slaughtering the master teacher and all his remaining pupils – save one. The only survivor, Wang Yu swears

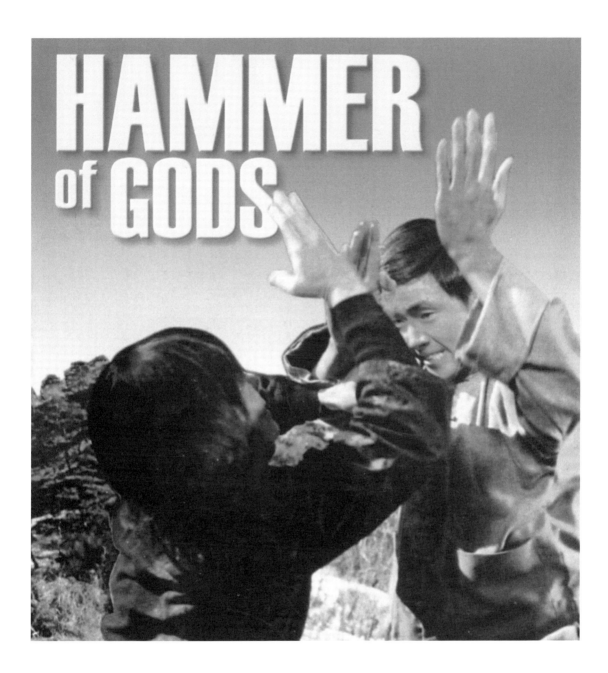

HAMMER of GODS

vengeance and goes to a deserted, spooky monastery to discipline himself in the way of the Iron Palm. These ascetic training scenes, including plunging arms into red-hot coals, are contrasted with the sleazy crimes and decadence of the villain – now casino boss – and his cronies, including rape. Then, disguised in white mask and gloves, Wang Yu makes his return.

After beating up various casino thugs and torching the building, he sets up a confrontation in the remains of the casino. All the customers clear out and he faces a vast mob of black-clad assassins single-handed. Clearly a major inspiration for the "House of Blue Leaves" showdown scene in Tarantino's *Kill Bill 1*, this frantic set-piece ends with Wang Yu victorious and the casino littered with dead or unconscious

One-Armed Boxer

bodies. Wang Yu sends a message to the villain and his cohorts to meet him the following day. The next day, in the snow-driven countryside, he is confronted by a gang of samurai-sword wielding killers. Finally unmasking himself, he takes on his opponents in the long grass, picking them off one by one – including one spectacular decapitation – before bloodily butchering the Japanese sword-fighters. The crime boss narrowly escapes. This scene, and the introduction of the two samurai swordsmen who demonstrate their skill by slicing to pieces a group of uncaged birds, is Wang Yu's only serious nod to armed combat in **Chinese Boxer**.

The film's climax comes with a final confrontation between Wang Yu and the three karate-killers. As he faces them down in the snow, he is unaware that the treacherous casino boss is lying in ambush behind him. Finally removing his white gloves, Wang Yu employs the Iron Palm technique to kill two of the Japanese with some bloody ocular destruction and body-pulping. A lengthy climactic fight with the toughest karate-killer ensues. Just as Wang Yu is winning, having punctured his opponent's chest with an iron punch, the boss comes up and stabs him from behind. Though badly wounded, Wang Yu pulls out the knife and fatally skewers his enemy before succumbing to a rain of furious blows from the Japanese. As the karate-killer starts to gloat, sensing victory, Wang Yu summons a final reserve of strength; leaping high into

the air, he delivers a death blow — his fingers plunging into his opponent's belly and withdrawing in a fountain of blood. The film closes as he limps away, bloodied but unbowed.

His motivation by revenge is a given in the genre, but **Chinese Boxer** anticipates Wang Yu's later tournament-based films in that his conflict with the Japanese is also less racial than based on a rivalry of fighting styles; to rid his town of these killers, Wang Yu must demonstrate that Chinese boxing can overcome karate. Wang Yu followed **Chinese Boxer** with a sequel of sorts which also incorporated his "one-armed" persona from the earlier swordfight movies; the resulting hybrid, unsurprisingly titled **One-Armed Boxer** (1971), remains one of the most action-packed kung-fu movies of the decade, whilst both establishing the classic the kung-fu tournament movie format and signalling the start of Wang Yu's use of "fantasy" elements to exaggerate the skills of the fighters, allied to the masochistic streak which also surfaces in the likes of Lung Kin's **Ten Fingers Of Steel** (1973, where he is crushed by a boulder).

In **One-Armed Boxer** Wang Yu himself plays Tien Lung, star pupil at the martial arts school of master Hang Tui. After two skirmishes with the local opium dealer Chao and his thugs, which Chao loses, the school is destroyed in a bloodbath when the treacherous villain returns with a gang of hired foreign mercenaries. Tien Lung is the only survivor, but one of his arms has been chopped off. Hell-bent on revenge, Tien is helped by a herbalist who teaches him the iron-hand fighting technique and *tai chi* death grip. The rest of the movie focuses on Tien's showdown with the exotic fighters, who include two Tibetan lamas with a weird inflation technique, a brutal *taekwondo* fighter, a judo expert, two Thai boxers, a fanged Japanese karate master, and an Indian yogi whose speciality is circling the opponent by walking on his hands, going ever faster and faster. Tien is able to match this by doing the same, only on one finger! This, and some of the other displays, heighten the almost supernatural element of the exchanges as the one-armed Tien matches his enemies blow for blow, finally wiping them out in a relentless barrage of violence.

Soon after this, when Run Run Shaw finally managed to sell his movies **T'ien-hsia ti-yi ch'üan (King Boxer** aka **Five Fingers Of Death**, 1971) and **Da sha shou (Sacred Knives Of Vengeance** aka **The Killer**, also 1971) to Warner Brothers, the floodgates to the West were well and truly opened[2].

The Killer

Lo Lieh, **Five Fingers Of Death**

Five Fingers Of Death is the most famous starring vehicle for Lo Lieh, one of the emerging stars in Hong Kong at the time. Another film which uses the tournament/revenge format to showcase anti-Japanese violence as well as internecine fighting between rival Chinese factions, it remains notable for its use of the *Ironside* theme, accompanied by a sinister red glow, each time Lo Lieh prepares to utilise his lethal Iron Fist killing technique. **Five Fingers Of Death** also features a high level of violence, including decapitations, bloody stabbings and sword-slashings, eyeball plucking, flying headbutts, and bone-crushing amid the general carnage. It went on to be one of the highest-grossing movies in the USA in 1973, and was key in instigating the kung-fu movie craze in the West.

The Bruce Lee vehicles **Fist Of Fury** and **Way Of The Dragon**, both Raymond Chow/Golden Harvest productions, followed soon after the initial wave inaugurated by **Five Fingers Of Death**. Lee was instantly established as the first global kung-fu superstar, a position consolidated by the almost simultaneous release of Warners' **Enter The Dragon** with Lee's untimely death, which quickly triggered an avalanche of sleazy copy-cat movies [see Part Two, Chapter 6].

Although the kung-fu (or "chop-sockey") phenomenon quickly petered out in the West, it persisted in Hong Kong. Avoiding the often expensive period excesses of King Hu's costume epics, these

Intimate Confessions Of A Chinese Courtesan

modernistic movies were cheaper to produce and therefore much more profitable for smaller companies. Films like Chiang Hong's **Headcrusher** (1972) and Ho Menga's **Death Kick** (1973) were churned out relentlessly. Even Shaw productions such as **Intimate Confessions Of A Chinese Courtesan** (1971) were not immune to the kung-fu craze. Director Chu Yuan somewhat bemoaned the fact that he was forced to insert kung-fu action scenes in what was basically an erotic revenge story with lesbian overtones, albeit with some climactic eruptions of swordplay. He compensated by inventing a technique called "ghost hands", in which fingers penetrate an opponent's body. **Intimate Confessions...** is actually one of the best, most unusual films of the period; visually sumptuous, timeless, phantastic, and imbued with a heavy erotic charge, it also features some bloody scenes of slaughter at times reminiscent of the classic Japanese production **Lady Snowblood**.

Angela Mao, **Lady Whirlwind**

Homegrown stars to emerge during this period included a second wave of girl fighters such as Shih Szu, Nora Miao, and, especially, Angela Mao[3]. Shih Szu after graduating in **The Crimson Charm** (1969) and **Lady Hermit**, went on to star in **The Young Avenger** (1971) – as a girl training for ten years to master the "poisonous dragon" technique – and in **Thunderbolt Fist** (1972) as Red Butterfly, a martial arts teacher bent on revenge against Japan. She also worked with Chang Cheh in several movies, appearing in his **Bloody Fists** (1974) amongst others. Nora Miao appeared in **The Blade Spares None** (aka **Woman Fighter**, 1969) and Lo Wei's **The Invincible Eight**, **The Hurricane** (both 1970) and **The Comet Strikes** (1971), before landing a role opposite Bruce Lee in **Fist Of Fury**. Perhaps the most internationally famed of the girl stars was Angela Mao (not least due to her 1973 role as Bruce Lee's sister in **Enter The Dragon**). After appearances in the supernatural thriller **Angry River** (1970) and **The Invincible Eight** alongside Nora Miao, Mao starred in two top Golden Harvest action films, **Lady Whirlwind** (aka **Deep Thrust**, 1971), and **Hap Ki Do** (aka **Lady Kung Fu**, 1972). **Hap Ki Do** was the best known in the West, where – under the strangely inviting tagline "Here Comes the Unbreakable China Doll Who Gives You the Licking of Your Life!" – audiences were impressed by her dazzling array of kicks, blocks and neck-crushing foot grips used to defeat and humiliate male (Japanese) aggressors. In 1973 Mao went on to make the similarly themed **When Taekwondo Strikes** (aka **Sting Of The Dragon Masters**) and then **Blade Of Fury**, although her career thereafter never quite reached the same level of momentum.

Ti Lung, David Chiang; **The Deadly Duo**

Despite the kung-fu boom, swordplay movies were still being made. Shaw Brothers were quick to replace Wang Yu with not one but two new stars: David Chiang and Tung Li, who acted in a series of action films directed by Chang Cheh from 1970–73 which included **The Deadly Duo** (1971), **The Pirate** (1972), and **Blood Brothers** (1973). David Chiang reprised the mantle formerly worn by Wang Yu when he took the part of **The New One-Armed Swordsman** in 1971. Chiang plays Lei Li, a sword-fighter who cuts off his own arm in shame after defeat by a false martial arts master and retires to the humble life of a servant. Despite his assertion that "ordinary people are happier than swordsmen", he is lured back to fighting ways by master swordsman Feng (Ti Lung). The film examines the fraught relationship between the two, one confident and super-skilled, the other dark, withdrawn – and crippled; but as usual, the fight set-pieces are the real highlights. Both occur inside the sinister Tiger Fort, where Ti Lung is hacked to bits by a mass of armed guards, and where Lei Li later unleashes a mass slaughter of revenge before defeating his martial arts nemesis. Chiang and Lung also appeared in some of Chang Cheh's more modernistic dramas such as **Vengeance** (1970), a grim and violent revenge tale set in 1920s Shanghai.

Wang Yu's own forays into the swordfight genre peaked in 1973, with his self-directed **Beach Of The War Gods** (Wang Yu had also in the meanwhile reprised his role as the one-armed swordsman, but this time in a 1970 Chinese/Japanese *chambar*a [swordfight] co-production **Zatoichi Meets One-Armed Swordsman**)[4]. **Beach Of The War Gods** is another story of Chinese versus Japanese, set in the Ming dynasty; Wang Yu plays Feng, a lone swordsman who almost single-handedly repels an army of

Beach Of The War Gods

Japanese pirates as they try to advance through a booby-trapped beach. The climactic swordfight is over twenty minutes long; at the end of it the beach is littered with dead bodies – Feng is the last to drop, finally killed by multiple wounds. A savage war-cry of a movie, **Beach Of The War Gods** was Wang Yu's ultimate epic of savage swordplay, anti-Japanese violence, and the tortured masochism which invariably found him mutilated, maimed and even killed as the result of his heroic struggles.

But it was two years later, in 1975, that Wang Yu (now and thenceforth credited as Jimmy Wang Yu) directed his masterpiece: **Master Of The Flying Guillotine**, a stone classic of psychedelic kung-fu. Featuring the return of his One-Armed Boxer character, this is another revenge- and tournament-based movie with a wild array of exotic fighters. Added to this is the crazed figure of blind, swastika-robed Manchu assassin Fung Sheng Lu Chi, who is the eponymous Master of the flying guillotine, a fearsome killing device first introduced in Ho Menga's patchy Shaw production **Xuedizi** (**Flying Guillotine**, 1974). The flying guillotine resembles a hat, equipped inside and out with razor-sharp blades, attached to a chain. When launched at a victim, it clamps over his head, the blades come down and with one flick, the head is severed. When One-Armed Boxer kills his two disciples, the Master sets out on a mission of revenge and recruits three exotic fighter to help him – a vicious Thai boxer, an Indian yogi (with "extensible arms" technique), and a cruel Japanese killer.

Master Of The Flying Guillotine

The central part of the film features a martial arts tournament, in which the three foreign fighters are involved. After several bloody bouts involving such human weaponry as killer hair, flesh-puncturing fingers and iron skin, the appearance of a one-armed fighter prompts the appearance of Master Fung Sheng, who has sworn to kill all one-armed men he meets. He duly decapitates the fighter with the flying guillotine, and also kills the tournament director, bringing proceedings to a shocking halt.

Next begins the hunt for the One-Armed Boxer, who first defeats the Indian yogi and then lures the Thai boxer into a house whose floor has been lined with metal plates. Once inside, fires are lit to heat the plates, burning the Thai's bare feet as he fights with the Boxer. He is duly defeated, and his charred body carried off. One-Armed Boxer next defeats the Japanese fighter, before the Master arrives and attacks him. Managing to blunt the flying guillotine's decapitator blades by using tough bamboo poles, the Boxer flees into town pursued by the vengeful Master. After a bizarre fight in a bird-filled aviary, they end up in a coffin-shop which the Boxer has rigged with hatchet-throwing devices. The fight continues, with the Master pierced by hatchets and the Boxer slashed by the guillotine's outer blades; at one point the Boxer hangs from the ceiling and throws pebbles in all directions to confuse the blind Master's super-

sensitive ears, only for his head to swivel around 360 degrees, **Exorcist**-style, as he follows the sounds. Finally, the One-Armed Boxer prevails: he delivers a killer iron-fist blow to the wounded Master which blasts him clean through the roof of the shop, to land dead in a conveniently positioned coffin in the street.

With its outrageous soundtrack of crunching krautrock, drumming and clattering, detonations and ricochets, allied to a visual orgy of zooms, surrealistic trick effects, neon pink flashbacks and bludgeoning violence – including decapitations, impalings, blindings and bone-crushings – **Master Of The Flying Guillotine** stands as one of most sensorially overwhelming cinematic experiences of the '70s.

Yet while 1975's **Master Of The Flying Guillotine** represents the pinnacle of Wang Yu's directorial achievements, his former collaborator Chang Cheh was only just starting on what would prove to be his most creatively productive years. Despite his success with the Shaw Brothers swordfight epics, Chang Cheh had left the Shaws in 1973 – taking David Chiang and Ti Lung with him – to set up his own studio and later inaugurate a new cycle of films upholding the pure kung-fu ethic. Variable in quality and often stylistically experimental, these included: **The Dragon's Teeth** (1974), **Shaolin Martial Arts** (1974), **5 Masters Of Death** (1975), **Shaolin Avengers** (1976), and **Death Chamber** (1976). **Shaolin Martial Arts** – one of the first movies to focus heavily on monastic kung-fu training – is notable for "introducing" actor and future star Liu Chia Hui (aka Gordon Liu); fight choreography was by Liu Chia Liang (aka Lau Kar Leung), who in 1975 would start his own series of unique films as director. **5 Masters Of Death** is also a notable entry, in that it started Chang Cheh on a series of films based on kung-fu "fighting teams".

This trope came to fruition in 1978 with two of the most bizarre and inventive king fu movies ever made: **Wu du (The Five Deadly Venoms)** and **Can que (Crippled Avengers)**. **The Five Deadly Venoms** is a relatively complex tale of internecine treachery between the five members of the notorious Five Venoms Clan as they compete to retrieve a hoard of "cursed" treasure. Each of the Venoms Clan is skilled in a certain bizarre form of kung-fu: Centipede (or "Thousand hands"), Snake, Scorpion, Gecko, and Toad. Gecko and Toad are the "good" fighters, who wish to distribute the treasure to charity, while Centipede, Snake and Scorpion seek it for their own gain and will stop at nothing to achieve their ambitions – including killing one another. From the start, the film presents a visually arresting succession of pulp imagery. The fighters, all wearing masks surmounted by an effigy of the reptile whose style they command, are first shown displaying their individual techniques. As the story unfurls, we see them in deadly combat against both "normal" folk and themselves; and we are introduced to outlandish torture devices like the "coat of a thousand needles" and the "red stomacher", and secret tools of killing such as the "throat barb" and "brain pin". The torture and killing is extreme and brutal, just as the fights between rival Venoms are complex and whirlwind-fast. In the climactic fight involving the four surviving Venoms (the Toad having been murdered) and their young understudy, Gecko (who can walk up walls) prevails after Snake, Scorpion and Centipede all turn on each other. Bizarre, bloody, cruel, bleak, yet presented in a surreally seductive style that mixes pulp and psychedelia, **The Five Deadly Venoms** is justifiably one of the most famous kung-fu movies of all time.

Toad vs Snake: **Five Deadly Venoms**

Crippled Avengers features the same acting team as **Venoms**, and is sometimes billed as **Return Of The Five Deadly Venoms** – this, however, is extremely misleading. **Crippled Avengers**, while overall less entertaining than its predecessor, actually raises the bar in terms of bloody violence in its opening third which is basically an escalating series of graphic mutilations. The film opens with an attack by the Tian New 3 Tigers on the villain of the story, Master Dao. They kill his wife by chopping off her legs, and mutilate his young son by hacking off his arms. Dao, master of the deadly Black Tiger 3 style, slaughters them upon his return. Some years later, Dao's son has been fitted with metal artificial arms and is proficient in bone-crushing kung-fu. Dao captures the sons of the 3 assassins he killed years before, and has his son cripple them. Next, as Dao and his entourage terrorize the local town, we see them embark on a new set of mutilations; first, a salesman is blinded, then the blacksmith is made deaf and dumb, then another man has his legs chopped off in the street. A fourth man, who tries to obtain justice for them, is made into an imbecile by brain-crushing. Thus ends an incredibly brutal sequence of events.

The middle third of the movie is taken up by kung-fu training sequences, as the four cripples[5] are rehabilitated by a master who fine-tunes the blind man's hearing and the deaf mute's sight, and has the legless man fitted with new iron limbs. The imbecile, though mentally retarded, has not lost his original

Crippled Avengers

kung-fu skills. Much of this training relies too heavily on acrobatics, and this part of the movie drags somewhat.

After 3 years of training, the four "cripples" are ready to take revenge on Master Dao. The last third of the film is a series of combat encounters between the crippled avengers and various members of Dao's entourage including his metal-armed son, his bodyguard Tan, who fights with a ball and chain, and Dao's nephew Jiu, an incredibly tough Qigong master. As with the training, most of these fights feature too many acrobatics, and are less convincing for it. The highlight is when Jiu, confident he can withstand three kicks and punches from each of the avengers, is shocked to discover than the last fighter really does have "iron" feet, which impale him fatally through the heart. The climactic battle between the four avengers and Master Dao sees the imbecile killed, but Dao ultimately subdued and, once again, killed by a fatal blow from the iron legs of the man whom he once had maimed. The end.

Crippled Avengers is somewhat less inventive both in plot and combat action than **Venoms**, but makes up for it by dint of the sheer cruelty and bloody violence of the opening mutilations and

Super Ninjas vs Gold Element Ninjas: **5 Element Ninja**

maimings. Added to some gory deaths amid the acrobatics, this makes yet another film of visionary violence from Chang Cheh.

But Chang Cheh was not quite finished yet. In 1982 he came up with **5 Element Ninja** (aka **Chinese Super Ninjas**), a film which , if it's possible, even surpasses his previous films in terms of non-stop, ultra-violent action and visual invention. The story concerns two rival schools who clash in a tournament. One school introduces a Japanese samurai, who is forced to commit ritual suicide when he loses a bout. Before he dies, he instructs his employer to contact his allies, the 5 Element Ninjas. The ninjas issue a challenge, and the best fighters of the school are sent to engage the Japanese foe. Each fighter finds himself outnumbered, and faced with the deadly tricks of the ninja warriors. The first ninjas are of the element gold; they dazzle their foe with whirling golden shields, which then fire deadly darts. The second element, wood, conceal themselves in trees and strike with deadly blades; the third, water, attack and kill from beneath a river; the fourth, fire, blind their opponent with red smoke from fireworks; and the fifth element, earth, conceal themselves underground before striking upwards with deadly spears. This latter segment is the bloodiest so far, with the Chinese fighter's entrails dangling from his stomach as he fights on with fatal wounds before collapsing.

Back at the school, the remaining fighters prepare to repel another ninja attack. Unfortunately, a

girl they have sheltered turns out to be a Japanese spy, who sends her ninja comrades details of the school's lay-out. The ninjas launch an irresistible nocturnal raid, during which all but one of the fighters are slaughtered, and the school's master burnt alive. The surviving fighter, Chin Hau, manages to escape and seeks out a Chinese ninja master. At the master's fortified enclave he meets and trains with 3 new "brothers". Meanwhile, the chief ninja turns on his employer, butchering him and his troops and taking over his school. But before long, he is visited by Chin Hau, who issues a new challenge: he and his 3 brother fighters will fight the 5 Element Ninjas in a duel to the death the next day.

That night, Chin Hau is followed by the Japanese girl, who attempts to seduce him; but realizing she has come with four ninja assassins, he stabs her to death before slaughtering her cohorts. The following morning, the duel with the 5 Element Ninjas commences.

Using fearsome silver weapons which serve multiply as axes, scythes, pikes, spears and stilts, the 4 brother fighters overcome the gold, wood, water, fire and earth ninjas in a series of bloody encounters featuring impaling, dismemberment and quartering amongst the violent deaths inflicted. Finally they are left to fight only the master Japanese ninja, who was hidden underground with the earth ninjas. The master ninja is a savage opponent, and the Chinese fighters are all bloodied as the long fight continues. This amazing conflict is only ended when Chin Hau sacrifices himself by impaling his body on the ninja's spiked shoes so he can lock down his legs. His 3 comrades grab the ninja's shoulders, and with some violent wrenching, the Japanese master is ripped in half in a gushing storm of blood. Chin Hau also expires, and his 3 brothers end the film by furiously shattering a rock on which the 5 Element Ninjas had carved their emblem. Freeze-frame.

In **5 Element Ninja**, Chang Cheh took his trope of fighting teams engaged in frenetic mass conflict to a new level, involving not only the use of bizarre and complex weaponry and excessive bodily destruction, plus garish colors and heavy stylization, but also an almost supernatural element which gives the film a phantastic ambience, combining to make an overall impact which he could never surpass. It remains the apex of his combat movies, and of his career as a whole.

Meanwhile, other variations of martial arts had continued springing up throughout the 70s. Slightly opposed to the garish, almost comic-book epics of Chang Cheh and Wang Yu were a breed of film-makers more interested in portraying the more pure, disciplined side of kung-fu and other combat forms. Filming the swordplay novels of Taiwanese writer Ku Lung, beginning with **Liu-hsing, hu-tieh, chien (Killer Clans**, 1976) and continuing with the likes of **Tien ya, ming yueh tao (The Magic Blade**, 1976),**Chu liu xiang (Clans Of Intrigue**, 1977), and **San shao ye de jian (Death Duel**, 1977), director Chu Yuan developed a philosophical/baroque strain of cinema, reminiscent both of 60s Hong Kong films and of the Japanese *chambara*. Yuan, whose earlier films had included **Ai Nu (Intimate Confessions Of A Chinese Courtesan**), **Da sha shou (Sacred Knives Of Vengeance** aka **The Killer**, 1972) and **Cha chi nan fei (Iron Chain Fighter**, 1975), imbues **Killer Clans** with an epic scope to encompass this complex tale of internecine underworld clans and the spies, assassins and double-agents who shift amongst them. Unlike the films of Chang Cheh, which often featured all-male casts, Yuan includes scenes of female nudity and sex amidst the impalings and decapitations. With hidden tunnels,

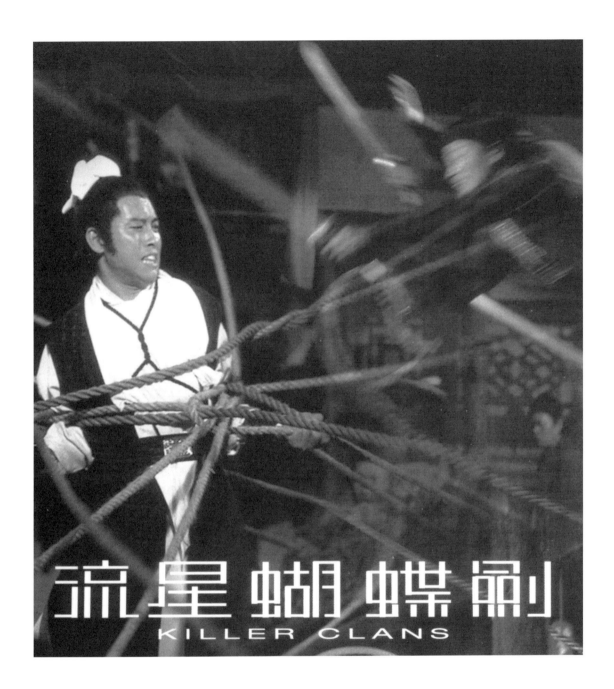

KILLER CLANS

multiple betrayals and arcane secret weaponry, **Killer Clans** never fails to engage the viewer as it reveals the workings of cult societies operating outside the law and governed only by the ability to kill or be killed.

Fight instructor Liu Chia-liang took up directing and pioneered a blend of tradition and trash in such films as **Shen ta (Spiritual Boxer**, 1975) and **Hung Hsi-kuan (Shaolin Executioners**, 1977). **Spiritual Boxer** has the dubious distinction of sowing the seeds of a new approach to kung-fu, an approach that veered towards comedy. This more irreverent approach finally gelled in two 1978 films by director Yuan Ho-p'ing: **She-hsing tiao shou (Snake In The Eagle's Shadow)** and **Tsui ch'üan**

Gordon Liu, Lo Lieh; **Fist Of The White Lotus**

(**Drunk Monkey In The Tiger's Eyes**), which quickly established their star, the ludicrous acrobat Jackie Chan. **Shaolin Executioners** is notable for the first appearance of the character Pai Mei aka White Lotus, the white-haired whip-browed kung-fu monk who, as played by Lo Lieh, also appeared in Ho Menga's **Shaolin Abbot** aka **Slice Of Death** (1979), and Lieh's self-directed and superior **Fist Of The White Lotus** (1980). Also starring Gordon Liu – who would play Pai Mei in **Kill Bill 2**, years later – **Fist Of The White Lotus** is one the most phantasmal of all kung-fu movies. White Lotus, known as the Iron Ghost because of his qualities of elusiveness and invincibility, is one of the greatest villains in the genre, and the climactic battle between him and Gordon Liu (using Crane style) is amongst the ultimate conflicts of good and evil.

Liu (then billed as Chia Hui Liu), was also the star of Liu Chia-liang's follow-up to **Shaolin Executioners** – the classic **Shao Lin san shi liu fang** (**Shaolin Master Killer**, 1978). **Shaolin Master Killer** is regarded as the ultimate kung-fu "training" film, which follows the complete training of novice monk Yu Te (Liu), who is bent on revenge against those who killed his family. This section of the film, running to almost an hour, shows him working through the 35 chambers of Shaolin over a period of 5 years. Here he learns balance, builds up his strength, and learns multiple armed and unarmed combat techniques, all of which are shown in fascinating detail. At the end, Yu Te (now known as San Te) instigates his own new 36th chamber, where other novices can be trained against the murderous treachery of assassins. The second part of the film depicts San Te finally exacting his revenge, aided by the "new wave"

Master Killer

of 36th chamber disciples. This was the film which really established Liu as a kung-fu superstar, and he went on to appear in countless other movies during the next 25 years, before consolidating his reputation in the West by guesting in Tarantino's **Kill Bill**.

Sadly, the majority of Chia-ling's other films are marred by a trashy, grating gratuitous "humour" which really spoils their dramatic integrity; one notable exception being 1984's **8-Diagram Pole Fighter**, an unswervingly bleak and violent picture and probably Gordon Liu's most powerful performance. Despite being highly stylized and theatrical (the film is shot against painted backgrounds and intricately choreographed), **8-Diagram Pole Fighter** starts at a high pace and builds to a climax which has the cathartic power of all great tragedy, no doubt the result of the untimely death, mid-shoot, of Liu's co-star Alexander Fu Sheng in a car accident. The story is set during the Sung Dynasty. The highly honoured Yang family are betrayed by General Pan Mei and ambushed at the battle of Jinsha, resulting in the death of patriarch Yang Ye and 4 of his 7 sons at the hands of the barbarous Tartars. Of the remaining sons, one is captured, one escapes (Liu, playing Yang the 5th), and one returns home suffering from loss of sanity. Yang the 5th eventually stumbles into a monastery and, struck by a vision of Buddha, swears to become a monk. Having bloodily shaved his head and branded his scalp with incense burners, Yang trains in the pole-fighting art of the monks. Two events then set the film on course to its bloody finale: first, the

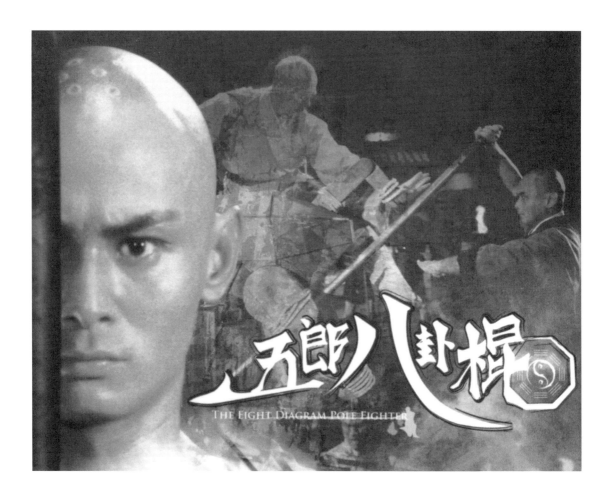

THE EIGHT DIAGRAM POLE FIGHTER

Master of the temple is ambushed by Tartars, and forced to kill himself, when he visits the Yang family to inform them of their 5th son's whereabouts; second, Yang's 8th sister sets off to find her brother, pursued by Pan Mei and his troops. When she is captured at an inn near the temple, Yang swears to rescue her and avenge himself against the traitor Pan Mei. The resulting climactic showdown in the coffin-filled inn is exceptionally bloody; Yang impales many of his enemies with poles, before being subdued. At this point, he is aided by his brother monks. Their collective assault against the Tartars is marked by bizarre and brutal scenes of oral and dental destruction (their pole-fighting technique is known as "de-fanging the wolf"). Finally, Yang and his sister close in on Pan Mei; she slices the skin from his face with the Yang golden knife, and then Yang propels him head-first through a coffin with malevolent force, killing him outright. His revenge complete, Yang departs to wander the earth as an itinerant monk.

8-Diagram Pole Fighter remains perhaps the last great film of the golden age of pure kung-fu cinema. By the time it was released, the kung-fu/martial arts craze was generally in decline both in popularity and technical achievement, to be gradually replaced by a new wave of sex and horror or gunplay movies which eventually led to the modern era of the Hong Kong "Category III" (adults only) cinema, as epitomised by the likes of the Shaw Brothers' ultra-gory **Black Magic 2** (1976) and **Seeding Of A**

Ghost (1983), the erotic **Sex And Zen** (1990), and John Woo's bloody and ballistic gangster epics (eg **The Killer**, 1989). This trend was briefly reflected in the dying embers of the kung-fu genre which, no longer so lucrative in itself, was now being diluted by mixing with other cinematic strains, for example with weird horror in the likes of **Kung Fu From Beyond The Grave** (1982) and **Kung Fu Zombie** (1983).[6]

Whether or not the recent global success of films like **Crouching Tiger, Hidden Dragon** and new stars like Jet Li will ever lead to a new "golden age" of the martial arts movies they seek to emulate remains to be seen, but seems doubtful; a revival and reappraisal of the original and best, triggered by the likes of Tarantino's **Kill Bill**, would appear more likely. And few bodies of film are more deserving of a new, appreciative audience.

1. The Sino-Japanese war commenced in 1937, when the Japanese invaded Manchuria with genocidal intent. Soon the Japanese *kempei tei*, or secret police, lived up to their reputation for cruelty with arbitrary street executions, mass rape, internment in barbaric prison camps, prisoners used as live target practice, and other atrocities. Not all film-makers fled to Hong Kong, however; some stuck with the Chinese government, moving to Chungking. Meanwhile the occupying Japanese took over or built new production studios, using Chinese technicians to make such propaganda films as Kunio Watanabe's **Song Of The White Orchid** (1939), the dubious love story of a Chinese girl and a Japanese immigrant. Hong Kong film-makers have since retorted with such over-the-top, repellent atrocity movies as the Shaw Brothers' **Bamboo House Of Dolls** (1973, women tortured in a Japanese POW camp) and He Chi-Chiang's grisly **Man Behind The Sun** (1990, medical experiments carried out on live Chinese prisoners in the notorious Japanese Concentration Camp 731).

2. Note for example the last desperate attempt by Hammer Films to survive in the early 1970s by entering into two co-productions with Run Run Shaw (**Shatter** and **Legend Of The 7 Golden Vampires**, both 1974), and similar efforts such as the German co-production **Enter The 7 Virgins** (1974).

3. These screen heroines were the precursors of the more recent trend of gun-toting, kick-boxing girl-gang fighters, "deadly china dolls" as seen in such movies as Pao Hsueh-li's **Deadly Angels** (1980), Wong Chun's **Angel Enforcers** (1991), Wing Siu's **Avenging Quartet** (1992), and Johnny To's **Heroic Trio** (1993).

4. The initial **Zatoichi** cycle of *chambara* movies, featuring the adventures of the blind samurai Zatoichi, started in 1962 and ran right through to 1973. **Zatoichi Meets One-Armed Swordsman** was directed by Kimiyosha Yasudu and starred Shintaro Katsu as Zatoichi. This fusion of Japan and China's ultimate sword-fighting heroes – two "cripples" who forge an almost supernatural alliance – proved a great success both artistically and commercially. In the tradition of great samurai movies as epitomised by **Sword Of Doom** (1966) and **Lone Wolf And Cub: Baby Cart At River Styx** (1972), **Zatoichi Meets One-Armed Swordsman** features plenty of bloody carnage tempered by a perverse visual poetry and phantastic scenes such as the Swordsman running wildly across a row of treetops.

5. The actors in **Crippled Avengers** are, however, Chang Cheh's regulars and not actually crippled; it was left to another movie, Joe Law's **Crippled Masters** (1982), to feature a pair of genuinely deformed actors, Frankie Sum and Jackie Conn. In this prime slice of exploitational Freak Film, two men skilled in the arts of kung-fu are betrayed by their master and crippled for life, one left with no arms and the other with no legs. They learn to combine their martial arts skills and seek revenge against the evil master, who

Crippled Masters

is himself a wall-eyed hunchback. **Two Crippled Heroes** (1983) was more of the same, a kung-fu freakshow directed by Ling Akuri-Lu and staring another pair of deformed fighters, Wang Hop and Ka Hai.

6. One rare example of a "pure" combat film appearing and conforming to the new, explicit climate was Lan Nai Kai's **Rikki O** (1991, a Japanese co-production), a comic-strip adaptation of near-insane violence. Set in a futuristic men's prison, **Rikki O** features relentless scenes of fists being driven clean through heads and bodies, limbs severed with a single blow, eyeballs smashed out, intestines used as ropes, faces cut in half by serrated machetes or sheared off by buck knives or peppered with razor blades, heads demolished, bodies smashed to pieces, crushed, blown apart and – literally – ground into hamburger meat.

select filmography

ONE-ARMED SWORDSMAN (**Dubei dao**, 1967)
CAST: Wang Yu, Chiao Chiao, Chung-Shun Huang, Yin Tze Pan, Chuen Chan, Lei Cheng, Pei Shan Cheung, Hau Chiu, Siu Loi Chow, Mei Sheng Fan, Feng Ku, Chia-Liang Liu, Cliff Lok, Mars, Chia Tang, Di Tang, Feng Tien, Kwong Yue Wong, Chih-Ching Yang, Shi-Kwan, Yen, Chen Yen-yen, Cheung-Yan Yuen, Woo-ping Yuen.
CREDITS: Directed by: Chang Cheh; Written by: Chang Cheh, Kuang N; Produced by: Run Me Shaw; Original Music by: Fu-ling Wang; Cinematography by: Chen San Yuan; Film Editing by: Hsing-lung Chiang; Make-up by: Yuen Fang; Martial arts direction by: Liu Chia Liang (Lau Kar Leung), Tong Gai.

GOLDEN SWALLOW (**Hsia yu-yen**, 1968)
CAST: Cheng Pei-pei, Lo Lieh, Wang Yu, Hsin Yen Chao, Sek Kin.
CREDITS: Directed by: Chang Cheh; Written by: Chang Cheh; Produced by: Run Me Shaw; Original Music by: Fu-ling Wang; Cinematography by: Hsueh Li Pao; Film Editing by: Hsing-lung Chiang; Art Direction by Chi-Jui Chen; Make-up by: Yuen Fang; Martial arts direction by: Chia-Liang Liu, Chia Tang.

THE BELLS OF DEATH (**Duo hun ling**, 1968)
CAST: Yi Chang, Hsin Yen Chao, Ping Chen, Paul Chun, Feng Ku, Kau Lam, Ma Wu, Chih-Ching Yang.
CREDITS: Directed by: Yueh Feng; Produced by: Run Run Shaw.

A TOUCH OF ZEN (**Hsia nu**, 1969)
CAST: Billy Chan, Ping-Yu Chang, Roy Chiao, Shih Chun, Hsue Han, Yin-Chieh Han, Feng Hsu, Ching-Ying Lam, Tien Miao, Hong Qiao, Peng Tien, Cien Tsao, Pai Ying, Sammo Hung Kam-Bo.
CREDITS: Directed by: King Hu; Written by: King Hu, Songling Pu; Produced by: Jung-Feng Sha, Shiqing Yang; Original Music by: Tai Kong Ng, Dajiang Wu; Cinematography by: Yeh-hsing Chou, Hui-ying Hua; Film Editing by: Jinquan Hu, King Hu; Martial arts direction by: Yingjie Han, Yaokun Pan.

CHINESE BOXER (**Long hu men**, 1970)
CAST: Lau Chan, Lei Cheng, Kuan Tai Chen, Sing Chen, Yun Kin Chow, Mien Fang, Min Fong, Hak On Fung, Hsia Hsu, Pei Chi Huang, Chiu Hung, Lo Lieh, Jason Pai Piao, Chung Wang, Ping Wang, Wang Yu, Ching Wong, Wai Yeung, Cheung-Yan Yuen, Woo-ping Yuen.
CREDITS: Directed by: Wang Yu; Written by: ; Produced by: Run Me Shaw; Martial arts direction by: Tong Gai.

INTIMATE CONFESSIONS OF A CHINESE COURTESAN (**Ai Nu**, 1971)
CAST: Lily Ho, Yuen Bun, Hei Chan, Lap Ban Chan, Shen Chan, Alan Chui Chung San, Mien Fang, Mei Sheng Fan, Min Fong, Wen Chung Ku, Chung Shan Man, Peng Peng, Betty Ting Pei, Choh Lam Tsang, Lin Tung, Ching-Ho Wong, Chak Lam Yeung, Hua Yueh, Corey Yuen.
CREDITS: Directed by: Chu Yuan (as Yuen Chor); Written by: Kang Chien Chiu; Produced by: Runme Shaw.

FIVE FINGERS OF DEATH (Tian xia di yi quan, 1972)
CAST: Lo Lieh, Chuen Chan, Shen Chan, Mien Fang, Min Fong, Chiao Hsiung, Hsia Hsu, Pei Chi Huang, Wen Chung Ku, Chia Yung Liu, Wei Lo, Fei Meng, James Nam, Wang Ping, Feng Tien, Fat Tsui, Lin Tung.
CREDITS:
Directed by: Chang Ho Cheng; Written by: Lo Lieh Lo, James Nam, Chiang Yang; Produced by: Run Run Shaw, Run Run Shaw; Non-Original Music by: Quincy Jones; Cinematography by: Wang Yunglung; Martial arts direction by: Lau Kar Wing, Chan Chuen.

MASTER OF THE FLYING GUILLOTINE (Du bi quan wang da po xue di zi, 1975)
CAST: Wang Yu, Kang Kam, Chung-erh Lung (as Kun Yee Lung), Chia Yung Liu (as Ka Wing Lau), Lung Wei Wang (as Lung Wang), Tsim Po Sham, Fei Lung, Fu Chiang Chi, Pai Cheng Hau, Ming Fei Wang, Tak Chi Chen, Tien Wu Chu, Wai Hsiung Ho, Han Hsieh, Hsing Hsieh, Fong Lung (as Li Chien Min), Mao Shan, Kao Shan Shao, Kun Chang Teng, Chiang Wang.
CREDITS: Directed by: Jimmy Wang Yu; Written by: Jimmy Wang Yu; Produced by: Cheuk Hon Wong; Original Music by: Hsun Chi Chen; Non-Original Music by: Neu; Cinematography by: Yao Hu Chiu; Film Editing by: Ting Hsiung Kuo; Costume by: Chao Ken; Make-up by: Yu Chen Chao, Yuan Chun Yu; Martial arts direction by: Ka Liang Lau, Chai Yung Liu.

KILLER CLANS (Liu xing hu die jian, 1976)
CAST: Chung Wa, Chan Ping, Guk Fung, Norman Chu, Yueh Hua, Danny Lee Sau-Yin, Lo Lieh, Fan Mei Sheng, Cheng Lee, Cheng Miu, Wong Chung, Yeung Chi Hing.
CREDITS: Directed by: Chu Yuan (as Yuen Chor); Written by: Chu Yuan, Ku Lung; Produced by: Run Me Shaw; Original Music by: Yung-Yu Chen; Martial arts direction by: Cheung-Yan Yuen, Tong Gai.

MASTER KILLER (Shao Lin san shi liu fang, 1978)
CAST: Billy Chan, Lung Chan, Shen Chan, John Cheung, Wah Cheung, Nan Chiang, Yuet Sang Chin, Alan Chui Chung San, Norman Chu, Ging Man Fung, Hon Gwok-choi, Hou Hsiao, Hoi San Lee, Gordon Liu (as Chia Hui Liu), Chia Yung Liu, Lo Lieh Lo, Lao Shen, Wilson Tong, Austin Wai, Wang Wai, Fat Wan, Han Chen Wang, Yu Wang, Casanova Wong, Ching-Ho Wong, Yue Wong, Hang-Sheng Wu, Siu Tien Yuen, Yang Yu.
CREDITS: Directed by: Chia-Liang Liu; Written by: Kuang Ni; Produced by: Mona Fong, Run Run Shaw; Cinematography by: Huang Yeh-tai; Martial arts direction by: Chia Liang Liu, Tang Wei Chen.

THE FIVE DEADLY VENOMS (Wu du, 1978)
CAST: Sheng Chiang, Philip Kwok, Feng Lu, Pai Wei, Chien Sun, Meng Lo, Lung Wei Wang, Feng Ku, Tu Lung, Shu Pei Sun, Liu Huang Shih, Lao Shen, Lin Hui Huang, Ching-Ho Wong, Wan Han Cheng.
CREDITS: Directed by: Chang Cheh; Written by: Chang Cheh, Kuang Ni; Produced by: Mona Fong, Run Run Shaw; Original Music by: Chen Yung Yu; Cinematography by: Kung Mo To, Hui-chi Tsao; Film Editing by: Chang Hsung Lung; Costume by: Lia Chi Yu; Martial arts direction by: Lu Feng, Liang Ting, Robert Tai (Yee Tin).

CRIPPLED AVENGERS (Can que, 1978)
CAST: Kuan Tai Chen, Philip Kwok, Meng Lo, Chien Sun, Sheng Chiang, Feng Lu, Lung Wei Wang, Dick Wei, Jamie Luk.
CREDITS: Directed by: Chang Cheh; Produced by: Mona Fong, Run Run Shaw; Martial arts direction by: Phillp Kwok, Chiang Sheng, Lu Feng.

FIST OF THE WHITE LOTUS (**Hung wen tin san po pai lien chiao**, 1980)
CAST: Gordon Liu (Chia Hui Liu), Lo Lieh, Lung Wei Wang, Kara Hui, Hou Hisao, Ching-Ching Yeung.
CREDITS: Directed by: Lo Lieh; Produced by: Mona Fong, Run Run Shaw; Martial arts direction by: Lieh Lo.

FIVE ELEMENT NINJA (**Wu dun ren shu**, 1982)
CAST: Tien-chi Cheng, Tien Hsiang Lung, Meng Lo, Wai-Man Chan (as Hui-Min Chen), Chen Hei Psi, Wang Lieh, Ke Chu, Tai-Ping Yu, Li Wang.
CREDITS: Directed by: Chang Cheh; Written by: Chang Cheh; Produced by: Mona Fong, Run Run Shaw.

8-DIAGRAM POLE FIGHTER (**Wu lang ba gua gun**, 1984)
CAST: Gordon liu (Chia Hui Liu), Sheng Fu, Li-Li Li, Kara Hui, Ching-Ching Yeung, Lung Wei Wang, Chen-Peng Chang, Hou Hsiao, Phillip Ko, Ming Ku, Chia-Liang Liu, Chia Yung Liu, Te-Lo Mai, Yue Wong.
CREDITS: Directed by: Chia-Liang Liu; Written by: Chia-Liang Liu, Kuang Ni; Produced by: Mona Fong, Run Me Shaw, Run Run Shaw; Original Music by: Stephen Shing; Martial arts direction by: Liu Chia Liang, Lee King Chue (Ching Chu), Hsiao Ho.

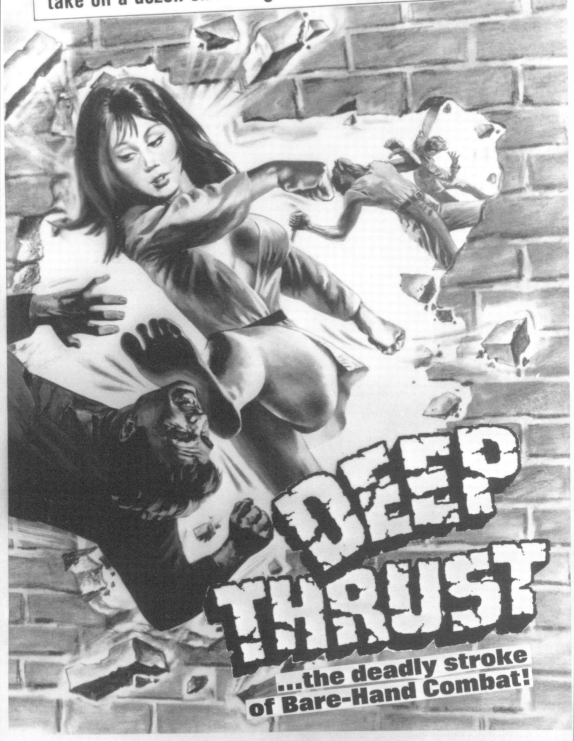

MISTRESS OF THE DEATH-BLOW!

SEE... the Deadliest Woman in the world take on a dozen skilled fighters bare-handed.

DEEP THRUST

...the deadly stroke of Bare-Hand Combat!

A HALLMARK Presentation · Color by DeLuxe® · An AMERICAN INTERNATIONAL Release

© 1973 American International Pictures, Inc.

ワン・ピー
ワン・テ
ナン・
世界で、最高の観客動員記録に輝く空手映画の決定版！

残酷！目玉抜き、脳天割り、五体骨砕き──黄金拳法の新登場！

ラン・
チャン・
武指導
チェン

キング・ボクサー
KING BOXER　大逆転

HERE COMES THE UNBREAKABLE CHINA DOLL WHO GIVES YOU THE LICKING OF YOUR LIFE!

ANGELA MAO
"LADY KUNG FU"

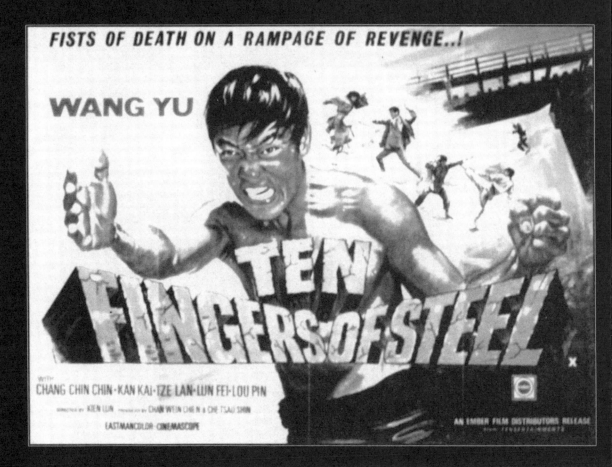

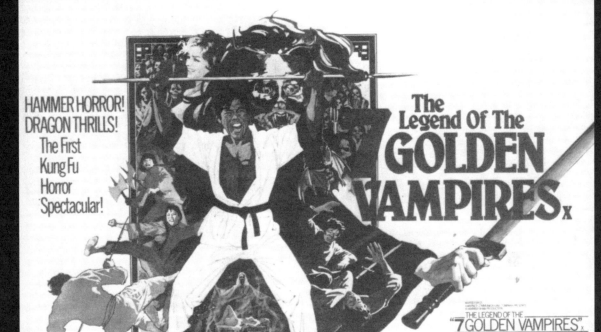

the films of bruce lee

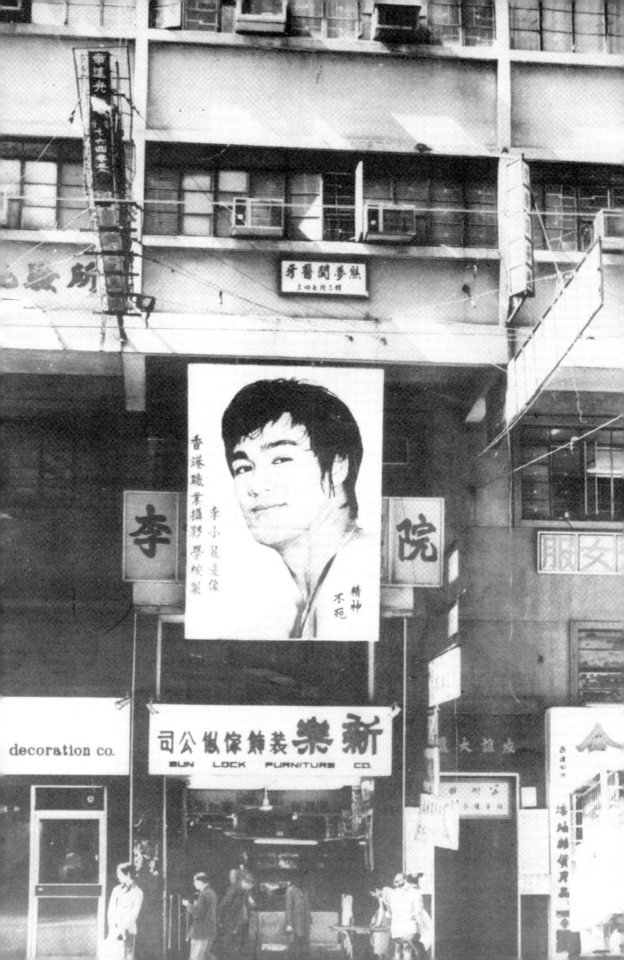

introduction

exit the dragon

6.45PM, July 20th 1973, Hong Kong: At the apartment of his lover, actress Betty Ting Pei, Bruce Lee complains of a serious headache. Betty gives him an Equagesic tablet, and he goes to lie down on the bed.

8.10PM, July 20th 1973: Betty goes to wake Bruce to get dressed for dinner. They're meant to be meeting producers Raymond Chow and George Lazenby at the Hotel Miramar to go over some ideas for Bruce's latest film, **Game Of Death**. But she can't seem to wake him from sleep. She tries shaking him desperately and slapping him across the face, but she can't get him to come round.

9.05PM: Raymond Chow, in the bar at the Hotel Miramar, receives a frantic phone call from Betty Ting Pei. He leaves the hotel immediately and drives straight over to her apartment on Beacon Hill Road, but due to traffic congestion, he doesn't arrive until about 9.40PM. He can't seem to get any response from Bruce, either. Betty calls her doctor, who takes one look at Bruce and summons an ambulance to take him to the Queen Elizabeth hospital. Betty stays with her mother and brother while Raymond Chow phones Bruce's wife Linda, and tells her to meet him at the hospital.

9.50PM: Linda arrives at the hospital. The ambulance isn't there yet. After a frantic wait, the vehicle arrives, sirens blaring. Paramedics are thumping her husband's chest, trying to keep his heart going. He's rushed into the emergency room and given stimulant injections, then electric shock pads. But it's all in vain. There's no response at all. Bruce Lee is dead.

"There are no limits, only plateaux. But you must not stay there; you must go beyond them. If it kills you, it kills you."
—Bruce Lee

Bruce Lee is born in 1941 in San Francisco, the fourth child of touring Cantonese opera star Li Hai-chü and his Eurasian wife Grace. Lee's original name (as it appears on his gravestone) is Li Chen-fan. Raised in Hong Kong, the baby Lee appears onscreen in 1941 as an extra in **Chin-men Nü (Golden Gate Girl)**, and after the family returns to Hong Kong in 1944, he continues his acting career as a child player in Mandarin films, going by the screen name of Li Hsiao-lung ("Little Dragon Lee")[1].

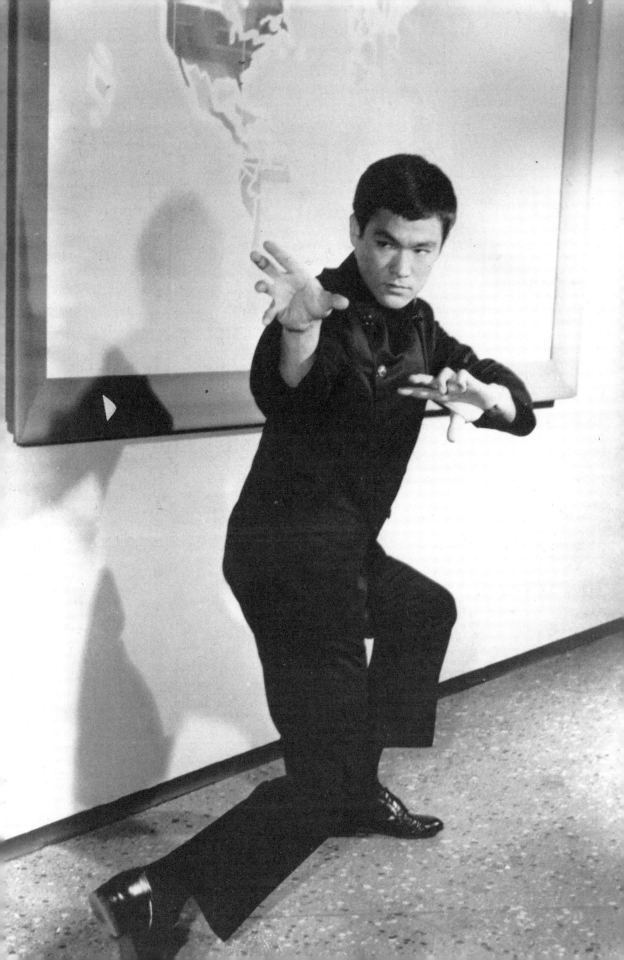

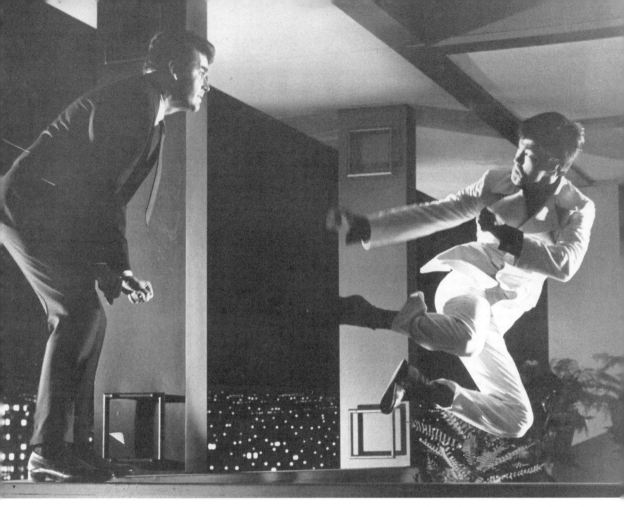

Bruce Lee in *The Green Hornet* (opposite) and **Marlowe** (above)

Lee soon grows into a tough little street fighter, ready to use his chains and knives in battles with rival gangs[2]. His interest in fighting leads him to take a course in kung fu, and other forms of combat technique, until he becomes obsessed with training, and with mastering the martial arts.

At the age of twenty-two, Lee finds work in the U.S. teaching self-defense. In 1964, at the age of twenty-three, he's spotted doing a kung fu demonstration at Long Beach by celebrity hairdresser Jay Sebring. Sebring remembers that one of his clients, TV producer William Dozier, is looking for an Oriental martial arts artist for the part of Kato in a new television series called *The Green Hornet* (1966–67). Sebring mentions Lee's name to Dozier, and Bruce lands the part, which soon leads on to some small appearances in movies. In between filming, he works teaching kung fu to actors like Steve McQueen, James Coburn and James Garner. He then plays a brief, but dynamic role opposite James Garner in the Raymond Chandler adaptation, **Marlowe** (1969), giving him the chance to display his martial arts prowess[3]. After filming the pilot for TV series *Longstreet* (1971–72), things look really promising when he's approached by Warner Brothers to play the lead in a new western/martial arts television series called *Kung Fu*, but when he's dropped in favor of David Carradine, he returns to Hong Kong, dejected and dispirited.

In Hong Kong, he accepts a call from Chinese producer Raymond Chow to star in a cheap martial arts picture called **T'ang-shan ta-hsiung (The Big Boss**, 1971). To everyone's surprise, the film turns

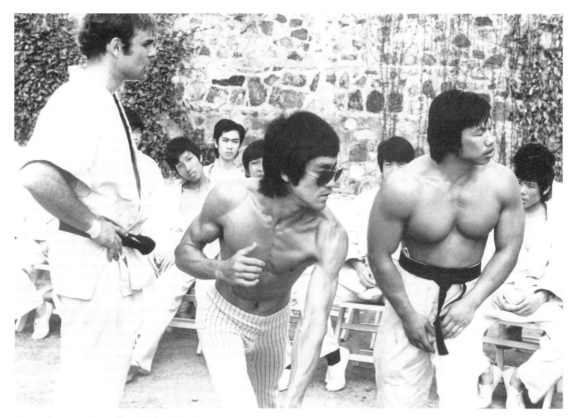

Bruce Lee on the set of **Enter The Dragon**

out to be a massive hit, and Chow follows it up with another, similar picture called **Jing-wu men (Fist Of Fury**, 1972), which is equally successful, and Lee starts to gain a reputation as "the king of kung fu". He goes on to direct and star in **Meng lung kuo chiang (The Way Of The Dragon**, 1972), which turns out to be a hit in the west, as well as the east, and initiates a whole spate of kung fu movies. His next film, **Enter The Dragon** (1973), is bankrolled by Warner Brothers and proves to be the greatest film of Lee's career. Warners offer to complete the suspended production of Lee's next film **Szu-wan yu-hsi (Game Of Death**, 1973/78), provided he agrees to sign a five-movie contract with them, and promise him a salary of $100,000 a year until his contract is completed.

And then, after filming a single cameo in **Ch'i-lin chang (The Unicorn Fist**, 1973), and only a couple of new fight scenes for **Game Of Death**, Bruce Lee, "the fittest man in the world", suddenly dies, and no-one seems to know how, or why. **Enter The Dragon** is released by Warner Brothers three weeks later. The film makes Bruce Lee into an international celebrity.

The official report claims that Bruce Lee has died from an "acute cerebral edema [brain swelling], due to the hypersensitivity to either meprobonate, or aspirin, or a combinations of the two found in Equagesic". The coroner delivers a verdict of "death by misadventure". It is, he claims, "a very sad case"[4].

Raymond Chow reveals that, during his filmmaking career, Bruce has taken a number of blows, some of which have been "quite severe". In fact, only two months prior to his death, he'd suffered a grave

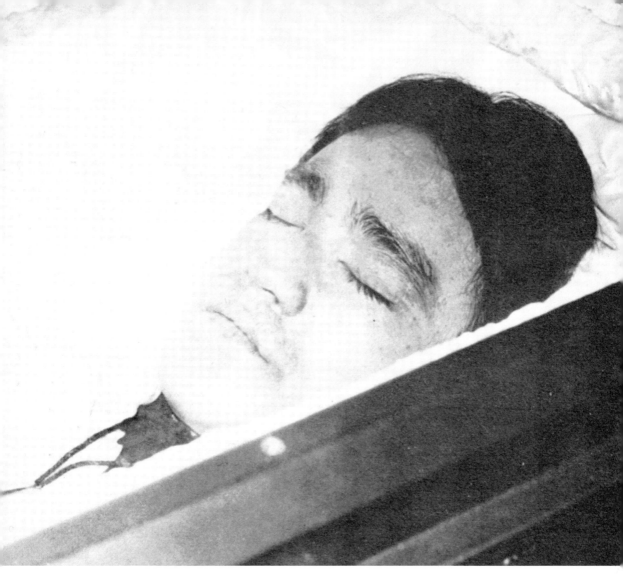

Bruce Lee at rest at the Kowloon funeral parlor

brain trauma, revealing a serious weakness that may have either been present from birth, or have been caused by a blow to the head. Many speculate that it's this pre-existing weakness that causes Lee's unexpected reaction to the Equagesic.

July 28th, 1973, Maple Street, Hong Kong: A huge group of people gathers outside the Kowloon funeral parlor for the largest funeral the city has ever witnessed. Lee's body is laid out in an open bronze casket, and three hundred policemen are deployed to control the crowds of mourners. Linda Lee arrives in traditional Chinese mourning clothes, a white robe and headdress, accompanied by her two children, Brandon and Shannon, each dressed in a little white robe of their own. Betty Ting Pei is not present at the funeral.

July 31st, 1973, Seattle: Bruce's body is flown to Seattle and buried at a small funeral in Lake View Cemetery. Celebrity pallbearers include Steve McQueen and James Coburn.

"Live life as if it is your last day"
—Bruce Lee to his son, Brandon

On the night of Bruce Lee's death, Raymond Chow announces to the press gathered at the Queen Elizabeth hospital that Bruce died at home, with his family. The first reports of his death repeat this story, one paper even going to far as to claim that he died peacefully, while walking in his garden with Linda. However, when ambulance call-out records reveal that the call has not come from Bruce's home but from the apartment of Betty Ting Pei, speculation about the cover-up begins immediately. Whether the misinformation is given simply out of a sense of respect for Lee's wife and family, or for other, more covert reasons, is never made clear. Not long after the autopsy, however, Hong Kong police discover a suspicious-looking parcel, with all the outward appearance of a bomb, bearing the words "Betty Ting knows the cause of Bruce Lee's death". The parcel turns out to be empty, but three similar packages are found later, each bearing a similarly suspicious written message, one of which reads "Revenge for Bruce Lee". As a result, the Hong Kong government orders a full-scale inquiry into the circumstances surrounding the star's death.

Suspicions are heightened when Betty Ting Pei emphatically denies that Lee died in her apartment, and when Raymond Chow refuses to make any further comment on the events to the press. Rumors begin to circulate that Lee has been murdered, or died under bizarre and unusual circumstances. And, as with most untimely or unanticipated celebrity deaths, speculation is hard to dispel.

The first rumor to circulate – and one that is initially given desperate credit by Bruce Lee's mother, Grace – is that the announcement of Lee's death is a publicity stunt to promote his latest film, **Game Of Death**. People lay bets on whether or not the announcement is true[5]. Such rumors, however, are quickly put to rest. And yet many Bruce Lee fans have little trouble believing the Chinese film industry would go to such morbid extremes in their quest to publicize a movie. These are the same fans that point out the unlikely coincidental connections between this film and the later death of Bruce Lee's son, Brandon. In **Game Of Death**, which is not released until 1979, it turns out that Lee plays the part of an actor who's shot after mobsters substitute a live round for a fake bullet on a movie set. This episode seems particularly ominous in relation to the death of Brandon Lee, who is killed in almost identical circumstances. In the days following Brandon's death, some of Bruce Lee's fans begin to watch the earlier film as a foreshadowing, both eerie and suspicious, of events yet to come.

A second set of rumors, and one not so easy to refute, is generated by the fact that small traces of cannabis are discovered in Bruce Lee's stomach during the autopsy. Stories are quickly generated about drug abuse, particularly since, in Hong Kong, the use of cannabis is regarded as worse than the use of heroin or opium. Some suggest that Lee may have used drugs to help accomplish his great feats of physical endurance; others imply that he may have been secretly given cannabis laced with some kind of poison. It is suggested that Lee may have antagonized certain people in the Hong Kong film industry, where his independent attitude could have stirred up too many ambitions in a previously closed and exploitative world. However, tests for evidence of poisons prove negative and, while the coroner finds no injuries to

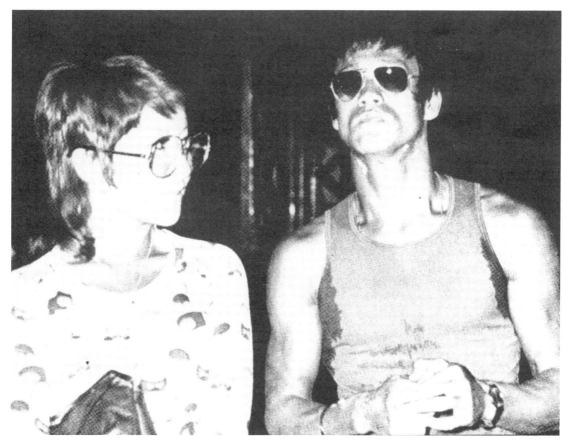

Betty Ting Pei and Bruce Lee

the skull or evidence of a brain haemorrhage, he discovers that Lee's brain has swollen very rapidly from its normal weight of 1,400 grams to 1,575 grams. The coroner concludes that death could not, however, have been caused by either cannabis or by cannabis poisoning, but is due to hypersensitivity to one or more of the ingredients of Equagesic. Nevertheless, speculation remains that Lee may have been poisoned with a secret herbal drug or medicinal herb known only to Chinese herbalists – a plant never heard of in the west, which could not, therefore, have been detected at the autopsy.

Some blame his death on too much work, others on too much sex – specifically, on an overdose of the aphrodisiac known as Spanish fly. More plausible, perhaps, are the implications that Lee has been murdered by members of the Chinese Triads who he may have crossed or offended, or that he's perished at the hands of Japanese martial arts artists who are tired of his critical attitude towards karate (as opposed to kung fu). Especially persistent is a rumor that Lee has been killed by a special "death touch" technique known only to the kung fu masters, who are angry with Lee for exploiting the secrets of the craft. Lee is often accused by his critics of bringing the martial arts into disrepute, and using the sacred procedure of kung fu for financial gain by capitalizing on its appeal to a mass audience. In Hong Kong, it is suggested, Lee has made many enemies by westernizing an ancient fighting style that is part of a deeply ingrained

Chinese family tradition, going back many generations, and embracing fierce depths of feeling.

The "death touch", otherwise known as the "delayed death strike" or the "vibrating palm technique", is a secret method of killing apparently known only to certain Shaolin monks and Ninjas, who have taught themselves over many years how to convert their internal energies into a wave of vibrations. This facility, a kind of reversed version of spiritual healing, is more akin to an occult art than a straightforward fighting move. The monk or Ninja has to simply touch the intended victim, who will then die at a pre-determined time, which could be anything up to ten years later. This capacity is supposedly a real one, and one which extends far beyond the physical realm.

Other persistent speculations include the theory that Bruce Lee is not dead at all, but has retreated to the mountains, or is alive and well and living somewhere in America, or that he died from taking steroids. Some claim he dies during an operation to have his sweat glands removed so he looks good on camera, or that he's the victim of a Mafia hit, having become too big to control. And author Bruce Thomas, in his book *Fighting Spirit*, has yet another theory:

"Did Bruce Lee simply burn himself out? Had the 'unlimited expression of his being' that Bruce found in his martial art turned inside out so that it was now these powerful forces that were moving him? Was the boy who could 'never sit still' unable to stop, so that at a very deep level his body could no longer handle what was taking place? As it came under increasing stress and demand, was his body pushed beyond its limits?"[6]

Significantly, the circumstances surrounding Lee's death include a number of ominous signals that seem to indicate that, in terms of traditional Chinese belief, at least, his body is not at rest. First, during its journey from Hong Kong to Seattle, Lee's casket is damaged. This is taken by some to be a prophetic indicator that Lee's soul is in turmoil. Next, it comes to light that the Chinese have a superstition that one should never put the word "death" in the title of a book or film, and on the night of his collapse, July 20th 1973, Lee is making plans to resume the filming of **Game Of Death**. Others comment on the fact that the name of the suburb of Kowloon Tong in Hong Kong, where Lee's house is situated, means "Nine Dragon Pond", and Lee's Chinese name means "Little Dragon". Some speculate that perhaps the Nine Dragons disliked having the Little Dragon in their midst, and wreaked a suitable revenge with a curse lasting for three generations. It also comes to light that Kowloon Tong has a reputation for bringing down wealthy families, symbolized by its situation at the lowest point of a depression in the land. Indeed, the two previous owners of Lee's house suffered extreme financial reversals. Bruce's *feng shui* advisor had been particularly unhappy with the house's location – deep in a valley on the landing approach to Kai Tak airport, where the natural air currents are profoundly disturbed. He also believes that the house is facing the wrong way. To counter these negative influences, a huge mirrored tiger is placed on the roof of the house. Two days before Bruce dies, the tiger is blown off the roof in a typhoon[7].

Bruce Lee the child actor (in **My Son A-Chang**)

1. A complete filmography for Lee's juvenile career is unavailable, but his early film appearances include: **Fu-kuei fu-yün/(The Beginning Of A Boy**, 1946); **Hsi-lu Hsiang (The Kid** aka **My Son A-Chan,** 1950); **Jen-chih ch'u (Infancy**, 1951); **Tz'u-mu lei (A Mother's Tears)**, **Fu-chih kuo (Blame It On Father)**, **Ch'ien-wan jen-chia (Countless Families)**, and **Wei-luo ch'un-hsiao (In The Face Of Demolition**, all 1953); **Ku-hsing hsüeh-lei (An Orphan's Tragedy)**, **Erh-nü chai (We Owe It To Our Children)**, and **Ku-erh hsing (Orphan's Song**, all 1955); **Cha-tien na-fu (The Wise Guys Who Fool Around)**, and **Tsao chih tang ch'u wo wu chia (Too Late For Divorce**, both 1956); **Lei-yü (Thunderstorm**, 1957); and **The Orphan Ah-Sam** (1958).

2. Lee has been quoted as confessing: "If I hadn't become a star, I would probably have ended up a gangster".

3. **Marlowe**, directed by Paul Bogart, is one of many versions of Chandler, with James Garner in the title role formerly essayed by Humphrey Bogart in **The Big Sleep** (and later by Elliott Gould in Robert Altman's **The Long Goodbye**). As henchman Winslow Wong, Bruce Lee plays two vivid scenes in the film; in the first he virtually destroys Philip Marlowe's office with a flurry of kicks and punches, and in the second he is goaded to his death by Marlowe, plunging from a rooftop after launching into a tremendous flying kick. Lee delivers his few lines with customary arrogance.

4. See Munn, Michael (1987), *The Hollywood Murder Casebook*, London: Robson Press, p157.

5. See Thomas, Bruce (1996), *Bruce Lee, Fighting Spirit*, London: Pan Books, p225.

6. Ibid., p255.

7. The aura of bad fortune surrounding the death of Bruce Lee seemed also to haunt the 1993 production of Rob Cohen's flattering biopic, **Dragon – The Bruce Lee Story**. The role of Bruce Lee was first offered to Lee's young son, Brandon,who turned the part down, more interested in pursuing an acting career as independent as possible from associations with the martial arts. The part eventually went to a young actor called Jason Scott Lee (no relation). According to Jason Scott Lee, a number of unanticipated disasters affected the film's cast within a brief two-month period, while Dragon was in pre-production. First, Scott Lee's grandmother died, then the producer, Rafaella de Laurentiis, lost an uncle she was very close to. Next, actress Lauren Holly, who played Linda Lee, lost her fourteen-year-old brother in a fire. Then director Rob Cohen suffered a heart attack that almost caused him to abandon the production altogether. "The whole impact of Rob's heart attack and those people in our lives leaving us just shifted our whole energy," claimed Jason Scott Lee in an interview with *People Magazine*. But this was nothing compared to the catastrophe that take place during the filming of **The Crow**, Brandon Lee's first major starring vehicle.

On March 30th, 1983, Brandon Lee was to film the scene in which his character, Eric, is gunned down by Funboy, one of the film's villains. The cameras started to roll. The director, Alex Proyas, had cameras filming the scene from two different angles, plus a video hookup in one camera to record the action for a quick playback. Michael Massee, who plays Funboy, was supposed to fire a .44 caliber rifle at Lee from a distance of about fifteen feet, and then Lee had to detonate a small squib – an explosive charge – planted in a grocery bag to simulate the effects of the bullet.

Lee/Eric, came through the door carrying his bag of groceries, and Massee fired the gun. The squib detonated, and Brandon slumped to the ground. The 75–100 onlookers broke into spontaneous applause. It was a wrap.

But then, something terrifying happened. Brandon didn't get up. Slowly, the onlookers began to realize the truth of the situation. Suddenly, it became clear that Brandon was bleeding profusely from the right side of his abdomen. Now there was panic on the soundstage. Somebody called for an ambulance, and, when it arrived, emergency technicians raced the unconscious actor to hospital.

In New Hanover Regional Medical Center, doctors found a silver dollar-sized bullet entry wound in Lee's right side. He was stabilized as best as possible, then rushed into surgery. For five hours, surgeons attempted to stem bleeding so severe that Lee needed to be transfused with sixty pints of blood, a full supply for five men, in order to repair what they discovered to be extensive vascular and intestinal damage. Somebody called Eliza Hutton, his fiancée, in L.A., who flew immediately to Wilmington. When she reached the Medical Center, Brandon had already been moved to the trauma-neuro intensive care unit, where he was still lying unconscious. He never woke up. Brandon Lee was dead at age 29.

chapter one

"the big boss"

TANG SHAN DA XIONG (1971; US release title: **Fists Of Fury**)
96 minutes
CAST: Bruce Lee (Cheng), Maria Yi (Mei); Han Ying Chieh (Mi); Tony Liu (Mi's Son); Malalene (Prostitute); Paul Tien (Chen, Cheng's Cousin); also featuring: Miao Ke Hsiu, Li Quin, Chin Shan, Li Hua Sze.
CREDITS: Director: Lo Wei; Producer: Raymond Chow; Screenplay: Lo Wei; Art Direction: Chien Hsin; Fighting Instructor: Han Ying Chieh; Cinematography: Chen Ching Chu; Assistant Directors: Chin Yao Chang, Chen Cho; Assistant Producers: Liu Liang Hua, Lei Chen.

DEBUT OF A LEGEND

As the sixties drew to a close, Bruce Lee was convinced that his future lay in America. His sidekick role in the TV series *The Green Hornet*, coupled with his *jeet kune do* classes had earned him recognition in Hollywood. He was teaching the likes of Chuck Norris, James Coburn and Lee Marvin; making guest appearances on *Ironside* and *Batman*; and studios were lining up with offers. However, they were having difficulty in finding the right project for Lee's unique martial arts talent. The best that Paramount could come up with was a supporting role in a TV pilot called *Longstreet*.

Bruce Lee had just turned thirty and his career wasn't progressing as fast as he wanted. He didn't want to play any more token roles on television and he didn't want to carry on teaching. His ambition was to star in a movie, and if Hollywood wouldn't give him a chance then maybe Hong Kong would. The first person he approached overseas was a movie mogul called Run Run Shaw. Lee proposed that he do one picture for Shaw Studios at a fee of $100,000, but he wanted to choreograph all his own fight sequences and have control over the script. Shaw laughed at him, reckoning that Lee was no different from the hundreds of Mandarin actors in his martial arts academy. Instead, Shaw offered him a considerably smaller contract that was identical to all the junior actors in his studio. Lee turned the offer down and returned to America, ready to start work on *Longstreet*.

Meanwhile, one of Run Run Shaw's executives, Raymond Chow, was becoming increasingly frustrated by Shaw's running of the studio. Shaw was a man who enjoyed his power and control, particularly when it came to the young actresses that came to see him. He would give these women private coaching, fulfilling what he saw as his "sense of duty". One such person, a singer called Mona Fong, had recently been promoted into a position of authority above Chow. This incensed Chow and he left Run Run Shaw to set up his own studio called Golden Harvest. The first few months of independence were an uphill

struggle. The Golden Harvest studios were little more than run down shacks, hidden away in the middle of nowhere. Most of the talent he managed to poach away from Run Run Shaw were either inexperienced amateurs or old drunkard hacks. To make matters worse, Shaw's stranglehold on all the big cinemas in the South East made it virtually impossible for Chow to distribute any of his films.

But Chow saw in Bruce Lee a great talent and, more importantly, an opportunity to reverse his fortune. He offered Lee all he could afford, a contract for $15,000 to star in two films made on location in Thailand. By this time, Lee had finished his work on the *Longstreet* pilot and Paramount were deliberating whether to commission a series or not. There was very little for Lee to do in between and here was an opportunity that had potential, so he accepted Chow's deal. When Run Run Shaw learnt about this, he offered Lee a more tempting contract, but Lee had already signed and was on his way to Bangkok. **The Big Boss** started shooting in July 1971 and would be the first of several collaborations between Raymond Chow and Bruce Lee.

"DON'T GET INTO ANY FIGHTS. REMEMBER YOUR PROMISE."

Cheng Chao-an (Bruce Lee) is brought to Bangkok by his Uncle Lu to live with his cousins, Hsu Chien, Lin Hau-mei and their younger brothers. Cheng and Uncle Lu stop for a drink at a roadside canteen. When five thugs start fooling around with the woman in charge, Cheng is tempted to protect her and fight them off, but Uncle tells Cheng to remember his promise. Cheng backs down and the thugs go on to threaten a boy selling rice cakes. A passer-by sees the fracas and fights off all five thugs. Uncle Lu recognises this good Samaritan as Hsu-Chien, and as soon as the thugs have disappeared, Uncle introduces the two cousins. Hsu-Chien takes Cheng and Uncle Lu back to the house to meet the rest of the family.

Hsu-Chien has plenty of brothers and one sister, Lin Hau-mei, who takes an instant shine to Cheng. Hsu-Chien has organised a position for Cheng to work alongside the rest of the family at the local ice factory. Cheng starts work and on his first day he makes a big mistake. He pushes a block of ice down the chute with too much force, making it drop over the side and smash. Two of Hsu-Chien's younger brothers, Tien and Wang, find bags of cocaine hidden inside. The foreman takes Tien and Wang to the manager, and the two brothers are offered money to remain silent. Tien and Wang refuse the deal, and the manager has them both murdered.

The next day, Hsu-Chien is curious about his brothers' whereabouts and asks the manager. He suggests that Hsu-Chien go see the boss at his home. This is the big boss of the title, Mi, a Japanese master of martial arts who trains all the thugs who work for him. When Hsu-Chien arrives with one of his brothers, Mi tries to fob them off with a story but Hsu-Chien doesn't buy it. Outside the boss's home Hsu-Chien and his brother are surrounded by Mi's thugs. After a brutal attack, they too are murdered.

In the morning, the rest of the brothers go on a search around the town. With no sign of their siblings, and increasing suspicion that they're being kept prisoner by Mi, the brothers take strike action. This ends up in a brawl between the workers and the manager's thugs. Cheng breaks his promise not to fight and gets involved, beating off all the thugs and sending them away. The manager is impressed by Cheng's abilities and decides to promote him to foreman. For the time being, this pacifies all the workers.

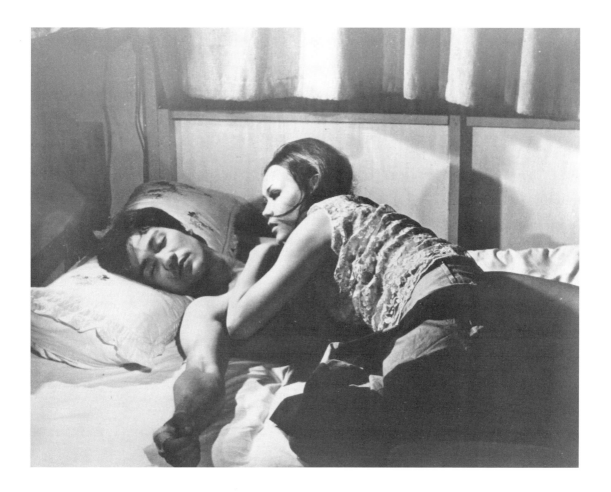

When the brothers return home to celebrate Cheng's promotion, it's Lin Hau-mei who reminds them all that Hsu-Chien and the others are still missing. Cheng promises to investigate next day by visiting the boss.

Later the following evening, the manager plies Cheng with drink. As Cheng becomes more drunk, he forgets all about Hsu-Chien's disappearance and eventually passes out for the night. Cheng wakes up in the morning lying next to a prostitute, and whilst running out of the brothel, he bumps into Lin Hau-mei. Cheng is speechless with embarrassment and runs off to the ice factory. The workers ask him whether he's found Hsu-Chien, but Cheng admits that he had a meal with the manager instead and forgot all about him. Now the rest of the brothers are disillusioned and decide to shun Cheng.

Cheng goes to Mi's house to make enquiries. Mi and his son put on an act of concern that fails to convince Cheng. He returns to the brothel and speaks to the prostitute from the night before. She tells Cheng that the ice factory is a front for smuggling drugs. Cheng goes to check out the factory, and after finding evidence of smuggling he discovers Hsu-Chien's body encased in ice. Meanwhile, Mi's gang kidnaps Lin Hau-mei and massacres the rest of the family. The gang arrives at the ice factory and Cheng defeats them all, killing Mi's son. Upon his arrival back at home, Cheng discovers the mutilated bodies of all his cousins but no sign of Lin Hau-mei.

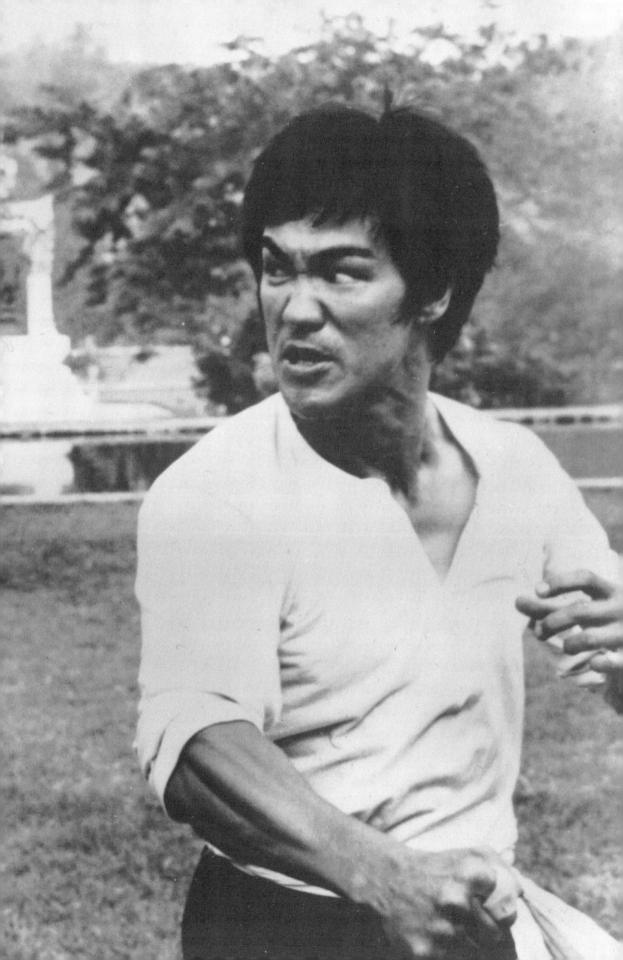

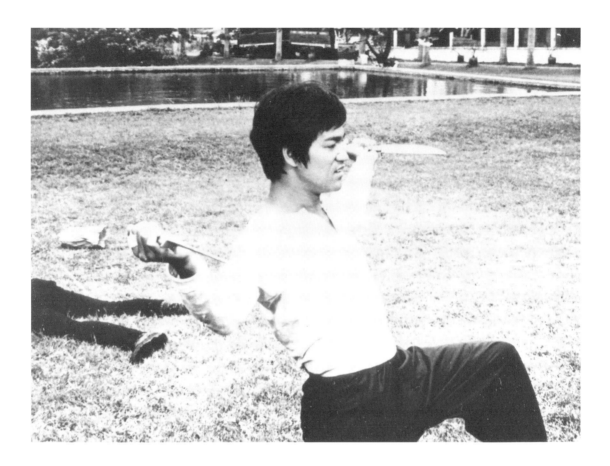

Cheng wages a vendetta against the rest of the gang, finally confronting Mi at his house. Lin Hau-mei is released by a fellow captive and fetches the police. Just as Cheng defeats and kills Mi, the police arrive and surround him. Lin Hau-mei pleads for Cheng to surrender, and the police drag him away.

During the first week of filming **The Big Boss** (known in the USA as **Fists Of Fury**), Bruce Lee and the rest of the crew were at odds with the director, Wu Chai Wsaing. Wsaing had a violent temper and a tyrannical attitude. Shooting would be delayed because of the antiquated camera equipment, and Wsaing would take out his anger on the crew. This bad feeling on the set exasperated any efforts made by the star to understand a script that was written on scattered pieces of scrap paper. Eventually, the production manager Mrs. Lo Wei insisted to Raymond Chow that they hire another director. As luck would have it, a certain Mr. Lo Wei was available for filming, and took over from Wsaing soon after the first week was over. Unfortunately, this didn't improve matters. Lo Wei was a compulsive gambler, more interested in the racetrack than the film. Because the sound was to be post-dubbed after filming was finished, he demanded that loudspeakers boom out racing commentary on the set whilst the actors were performing their scenes.

If things were bad already, they were about to take a turn for the worse. Lee suffered a twisted ankle after a bad fall, and whilst receiving treatment in a local hospital he caught a flu bug. The bug

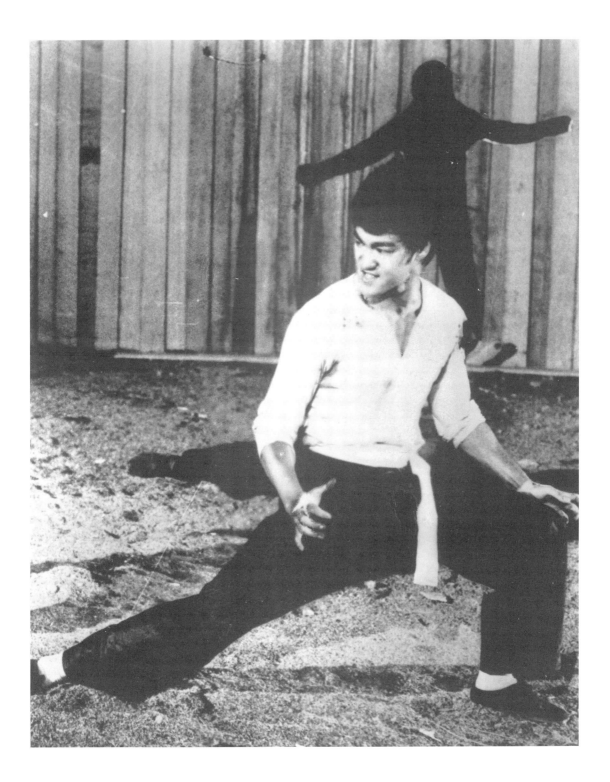

intensified Lee's back pains and he needed injections after each shot. Lo Wei was convinced he was working with a hypochondriac. Lee couldn't eat any of the local meat and ended up losing ten pounds during the rest of filming. But even though Lee's energy levels were flagging under the conditions, he still found

enough in reserve to take control of the script, and many of the fight sequences too, in order to bring order to the chaos.

If Lee disagreed with the way a fight scene was being staged, he would hamper it by looking around for a lost contact lens amongst all the debris in the ice factory. Not only did this tactic incense the director, but also the fight co-ordinator, Han Ying-chieh, who, as chance would have it, was playing the eponymous villain. Emotions ran high between these two throughout filming, thus making the final showdown between Cheng and Mi all the more intense.

Meanwhile, Chow and his partners in the Golden Harvest studio were facing bankruptcy. Towards the end of filming, the budget was running low and money for post-production was tight. Chow made a deal with Cathay Pictures, a distributor in direct competition with Run Run Shaw's studio, and got what little finance he could to finish the picture. From the opening credits, we can tell this is a film that has been made on a shoestring budget. The dubbing is extraordinarily bad and the editing looks as if it's been done with a pair of blunt scissors. But considering the film in context with the rest of Hong Kong cinema at the time, it's as if all of the flaws in the production actually work to make this a better film.

The demands of the story in the first half set up a tension where we know Cheng will have to disobey his Uncle's orders, and we as an audience already anticipate his first fight. This tension is stretched further as we watch Cheng stand away from the action during two fight scenes involving Hsu-Chien. But this delay in action allows Bruce Lee to reveal a side of his personality that is rarely seen in his other movies, particularly when he first meets Lin Hau-mei.

Uncle Lu starts telling stories from back home, and Cheng looks bored. He turns his head and sees Hau-mei looking at him. First, he's embarrassed at being caught out, then he rolls his eyes again before looking away. Hau-mei smiles and keeps watching as Cheng pretends to be bored. He eventually returns her gaze and smiles. She laughs, then turns away looking bashful. It's a small moment in total, but one in which Lee shows his ability to be both self-deprecating and charming.

Another example comes after Cheng saves Lin Hau-mei from Mi's libidinous son. Hau-mei runs to Cheng and holds herself close to him. Cheng wraps an arm round her and watches Mi's son go. Cheng's eyes slowly fall down to Hau-mei's and he looks nervous. Hau-mei looks up at him. As soon as they both realise their intimacy, they separate with comical shyness. Although Bruce Lee's timing for comedy is nowhere near as accomplished as his physical agility, he covers any cracks with a boyish naivete that is instantly endearing.

Within the story-frame, Lee creates a character reminiscent of James Dean's in **Rebel Without A Cause** – a man with a troubled history and a dangerous edge, but coupled with a humanistic need to be loved. But whilst James Dean searched for identity in middle class suburbia, Lee's hero is more working class, living in an agrarian community with an extended family. His internal conflict regards the promise he kept to his mother, the external conflict comes from the Japanese boss. It's Lee's portrayal of both these conflicts that is central to the success of the film. He brings all of his training as an actor in America to an Eastern cinema unused to his brand of realism.

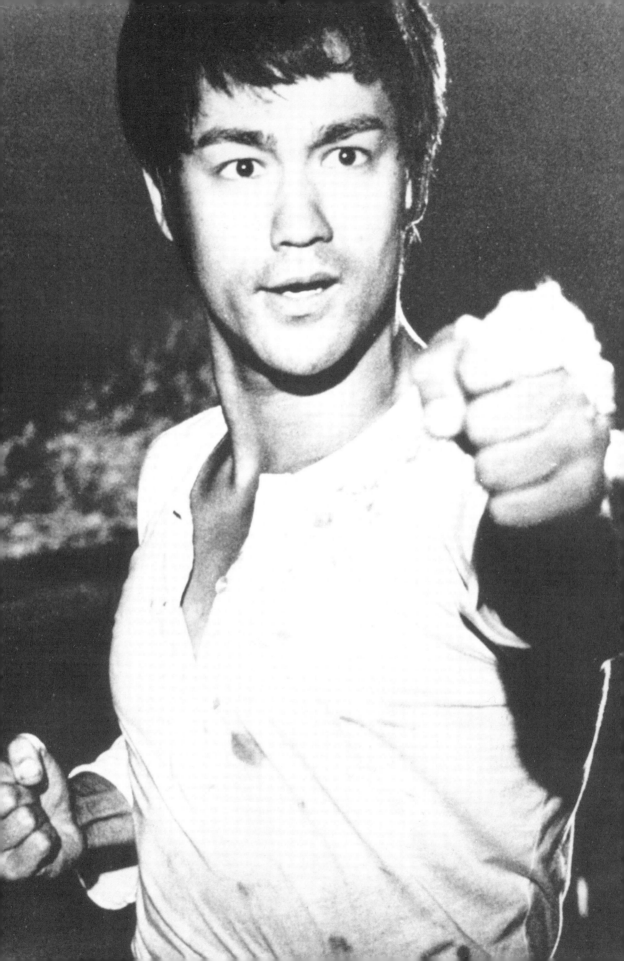

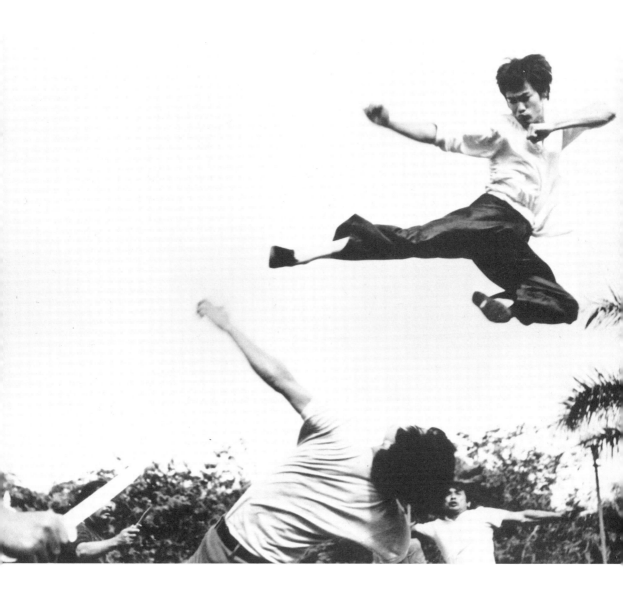

Prior to **The Big Boss**, kung-fu movies were more fantastical, set in historical legend and with less bloodshed. **The Big Boss** was completely new in that all the murders were shown in gory detail, the main villainy involved drugs and smuggling, whilst the texture of the film remained grainy and naturalistic. As for the moment when we finally get to see Cheng fight, it's imbued with so much of the tension that was prevalent in Hong Kong culture at the time that it's hardly surprising that Lee's performance spawned so many imitations.

"YOU WANNA FIGHT...? I'LL TAKE YOU ON!"

The workers are on strike. The foreman demands they go back to work but their spokesman, Ho Pei, says no – he wants to see the safe return of his brothers first. The foreman approaches Pei and threatens him with a baton, "Get to work!" Ho Pei pushes the baton aside, "To hell with you, you lousy pig!" The foreman

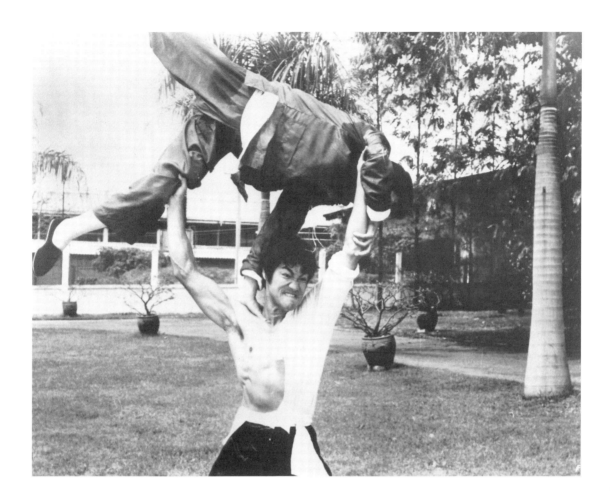

swings to attack, "Bastard!" Pei retaliates, the workers are all behind him, and a brawl ensues.

Cheng watches from a safe distance. We can feel the conflict inside him as he touches the amulet that hangs round his neck, the amulet from his dead mother.

Meanwhile, the manager has called in reinforcements, and the workers are close to defeat. Ho Pei pleads to him, "Cheng, don't just stand there – fight!" One of the thugs comes out of the fray and strikes Cheng with a metal hook. Cheng pushes him away. He feels something strange and looks down at his chest. The amulet has been torn off and broken. Cheng's blood boils and his face contorts in rage. He squalls a menacing, high pitched *kei* (fighting cry) before flying into action.

The climactic showdown between Cheng and Mi is driven by pure emotional hatred. After Cheng defeats Mi, he carries on punching and grinding him into the ground, murdering him over and over again. But before this victory can happen, there's something else going in the scene which satisfies a more hidden, more sexual tension.

We see Cheng and Mi size each other up. Cheng snarls, coos and flexes his forearms. He invites Mi, and the audience, to regard his prowess. He strikes first with two double kicks. Mi goes for a punch, but Cheng deflects him. It's in this moment that Mi rips off Cheng's shirt sleeve and we get our first

glimpse of Lee's torso. If there was tension from the beginning of the film that Cheng would resort to fighting, then a parallel tension has been resolved as soon as we see his naked body. We are allowed to see the extent to which Cheng, and Bruce Lee for that matter, has trained himself. We can admire and take pleasure from looking at his physical fitness. But before we take too much pleasure and start feeling guilty for it, his body is damaged and scarred. Cheng and Mi fly at each other and strike in mid air. Mi pulls out a knife and swipes at Cheng, ripping away the rest of his shirt. It's no mistake that his shirt is white, hanging around his waist whilst blood drips from his torso. The audience have seen the star fight and they've seen him naked, and now the film has satisfied those tensions, it can get on to its conclusion.

Three months after **The Big Boss** started shooting, it premièred in Hong Kong. Within three weeks of its release, it had already broken box office records by out-grossing **The Sound Of Music**, taking $3.2 million in 97 cinemas. The reason for this success is simple. In a society where most of the population were under twenty-five and illiteracy was rife, Bruce Lee came along and gave the working class a hero. There was a villain that was easy to recognise, a boss who owned their sweatshop lives, and an emotional climax that lived out the violent fantasy of the subjugated classes. Lee's portrayal of the working class, wandering Mandarin with a street-fighting talent was firmly endorsed by Hong Kong audiences, and he would repeat this character in future movies. More importantly though, Lee had set a trademark for the kung-fu film that was so fresh and at the same time tied into contemporary culture that it would only be a matter of weeks before the Hong Kong movie factory started churning out imitations.

Hollywood suddenly took an interest in this new genre, a genre that was easy to produce and that held a substantial profit margin – but Hollywood was too late for Bruce Lee. In the time it took Paramount to complete the pilot of *Longstreet*, and decide to commission a series, Lee had already made his name and reputation with the overwhelming success of **The Big Boss**. Now he knew for sure that his future lay in Hong Kong.

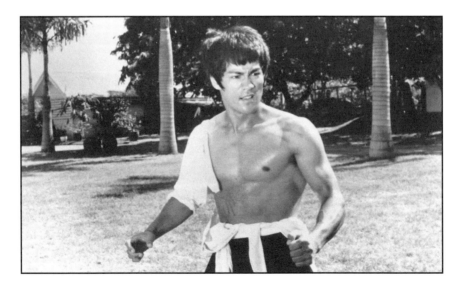

chapter two

"fist of fury"

JING WU MEN (1972; US release title: **The Chinese Connection**)
110 minutes
<u>CAST</u>: Bruce Lee (Chen Chen); Miao Ker Hsiu (Yuan Li-erh); James Tien (Fan Chun-Hsia); Robert Baker (Russian Boxer).
<u>CREDITS</u>: Producer: Raymond Chow; Director: Lo Wei; Cinematographer: Chen Ching-Chu; Assistant Producer: Liu Liang Hua; Production Designer: Lo Wei; Assistant Director: Chih Yao-Ching; Screenplay: Lo Wei; Editor: Chang Ching-Chu; Music: Ku Chi-Hui; Fighting Instructor: Hen Ying Chieh.

It is generally felt among many of Bruce's fans that **Fist Of Fury** was the best action movie made by him in his short and frantic film career. **Fist Of Fury** for the average fan was a rich blessing of action movie/martial arts of a type that had never been seen before in the United Kingdom.

Fist Of Fury, released in 1972 in Hong Kong (and the Far East generally) was released in the United Kingdom in late 1973, months after Bruce Lee's death. Many fans had already had the opportunity to see **Enter The Dragon** (Bruce's 4th movie) as it was released by Warner Brothers prior to Golden Harvest and United Artists releasing Bruce's other films in late 1973/74. So most people already knew who Bruce Lee was in the United Kingdom from this film.

Fist Of Fury was made for the traditional Eastern Market. It was typical for this market – very violent, low-budget, shot in less than a month on a back-drop film set in Shanghai. The producer, Raymond Chow, picked Lo Wei, who had previously directed Bruce Lee in **The Big Boss** (and who incidentally also wrote the script) to direct the film. Lo Wei's other action films included **The Shadow Whip**, **The Invincible Eight**, **The Hurricane**, and **Dragon Swamp**.

But it was not long before Bruce and the director were having verbal battles over the script and the general direction of the film. Bruce also had arguments with some of the little-known extras in the film. These arguments were quickly resolved by Bruce with a simple demonstration of his fighting skills.

The film was a landmark victory for Bruce; the film was an instant success and made him the new superstar of Hong Kong and the Chinese people. Soon his name would be a legend in his own right. This was Bruce's second film for the Hong Kong Eastern market, and was to be his best. Bruce's first film **The Big Boss** had been released in late 1971, to a box office records in China. Bruce was now the first Eastern film actor to command the word "star". Single-handedly he changed the Chinese film industry.

In Singapore on the first opening night, the film caused the first traffic jam in the country's history. The premiere of the film had to be postponed for a week to cool things down. The £1 tickets were

selling on the black market for upwards of £18 for the first showing of Bruce's film. In Taiwan, Bruce even picked up the Golden Horse Award for best acrobatic acting!

Fist Of Fury – Chinese title **Jing-wu men** – was made in 1972. The cast included many Chinese stars of the time including James Chun, Nora Miao, Maria Yi Fung and, of course, Bruce Lee as Chen. **Jing-wu men** was released in the United States of America as **The Chinese Connection**, and in Western Europe as **Fist Of Fury**.

The film begins with Bruce starring as Chen, a young martial arts student pushed to the edge by the death of his teacher. The opening scenes of Bruce dressed in white clawing at the soil as the coffin of his teacher is lowered into the ground showed that Bruce could act as well as fight.

Michael Kaye, who dubbed Bruce's voice in the film, stated that in Chinese films you never had to show any emotion. It was mainly fighting; a little plot, then another fight scene. (One has to remember that many of the Chinese films made during this time were shot on back-drops in Shaw Brothers studios. Films were shot and at times made up as they went along. Stars of the films were just actors churning out film after film with little or no plot, just plenty of kung-fu action for the Chinese audience.)

Bruce Lee was to change that stereotype once and for all.

Fist Of Fury continues with Chen in the aftermath of his teacher's mysterious death. Chen spends his time brooding over the senseless loss until the arrival of Wu (played by Wei Ping Ao), "translator" for the powerful Japanese, Suzuki (played by Riki Hashimoto), who runs a rival school. Wu first derides the class through ethnic slurs, then intimidates them with a warning and a challenge. The school is also presented with a framed statement proclaiming them to be weak men. This is a challenge Chen wishes to accept.

When his fellow students convince him otherwise, Wu taunts him, unaware of the fierce power behind Chen's unassuming appearance. Chen finds out that the two cooks who have poisoned the master are in fact Japanese infiltrators. He kills them both, leaving their bodies hanging from a lamppost in the town. This is the first time that audiences witness Bruce's famous power punching: rapid punches to the solar plexus, shot in slow motion as the camera pans to Bruce's contorted face of rage. This was another first in Chinese movies: true emotion in an action film with good all round acting. This was a skill Bruce picked up in the United States with his many television appearances, and connections with leading Hollywood actors.

Bruce saw his role on screen as an actor, but fans around the world demanded that Bruce be the superhero. He once remarked during filming of **Fist Of Fury**, that he was not the same person in each of his films, although when he fights he comes out the same – like an animal! **Fist Of Fury** proved that point with audiences around the world. Bruce always felt that the South East Asia films were a starting point for his fighting skill of *jeet kune do*; he also stated that his fighting was not violent, but based on action. In real life he would not have used an artistic approach to the flamboyant style of kung-fu as used in the film **Fist Of Fury** – he would have disposed of any opponent ruthlessly and quickly, like a streetfighter.

Seeking to right the wrongs that Wu has perpetrated, an angry Chen visits his violent

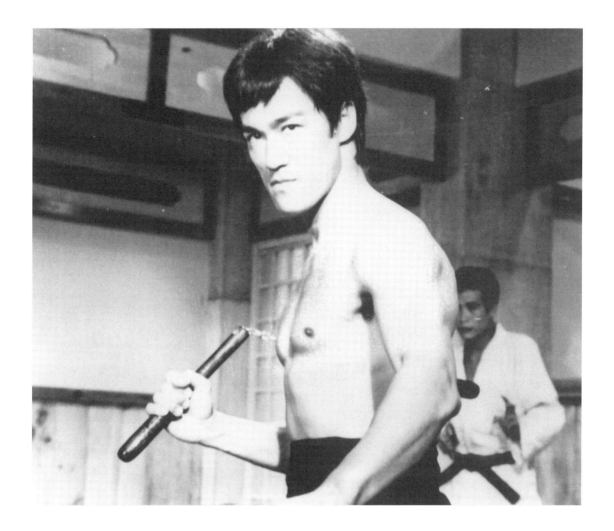

competitors. The immortal line: "we are not the sick men of Asia" – referring to the age-old persecution of the Chinese by Japan – brought Chinese film-goers to their feet, clapping and wailing during the first showing of the film. The film was saying to the Chinese people, "Look you are Chinese, you are as good as anybody – if not better". Lee became a new figurehead for Chinese pride, and clearly revelled in the role.

In one of the film's breathtaking action highlights, Bruce takes on the entire class, decimating them all without breaking a sweat. This also introduces the audience to Bruce's famous mastery of the *nunchuka* (rice flails). Many people who watch Bruce Lee films now will see that most of these scenes have been left out by the British censor, due to the upsurge of these weapons being used in gang fights in the 1970's; they were proclaimed to be dangerous and a bad influence. Many older fans, who have seen the original film, will know what a difference the cutting of certain scenes makes to the plot; in particular the ending.

Bruce often felt during the filming of **Fist Of Fury** that some of his co-actors were not being as cooperative as they could. Some of the actors were particularly worried about the *nunchuka* scenes, they

had never had to act where wooden sticks would be flying around during a fight scene. He eventually managed to persuade the film's stunt crew that with rehearsals the scene would be in the can with one take. This was not normal on a Chinese film; the action was usually shot with little rehearsal, and action stars were often hurt as a result. Bruce made sure this was not the case in his films.

Bruce would constantly practice with the *nunchuka* during breaks in the actual filming of **Fist Of Fury**. He would do this until his upper arms were black and blue with the force and speed of his actions.

Bruce spends a lot of the film as a brooding Oriental James Dean figure. You can see him first analyze the plot by the Japanese enemies, and then frantically explode into rage during the fight scenes. Yet Bruce was also able to turn a simple scene into something quite different. An example of this is in the scene where Bruce plays the telephone engineer. He used his own glasses, put on a hat, and gave a permanent grin, whilst cursing under his breath at the Japanese students.

Finally, an outraged Suzuki gives his enemies just three days to turn Chen over to him – or else! The police inspector (played by the director Lo Wei in a walk-on part) has a duty to abide by the laws of the Japanese community. The request is made to hand over Bruce for the death of their people.

The scene in which Bruce tries to enter the Shanghai Park, and is prevented from doing so by the park-keeper, is also a memorable piece of filming. There actually *was* a sign outside this park which stated

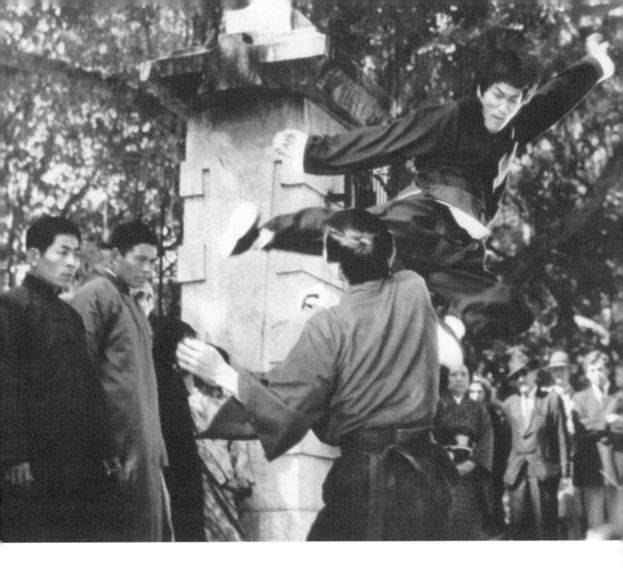

"no dogs or Chinese". Bruce punches the white faces of the *kwialos* and then proceeds to kick the sign off the wall and smash it into smithereens. Again, the Chinese film audiences clapped and stood on their seats when this anti-racist scene was shown.

The students urge Chen to leave Shanghai. When he overhears the truth about his teacher's death at Suzuki's orders, he refuses to go, choosing instead to avenge his master.

Chen adopts a number of disguises to elude the police inspector. He appears as a rickshaw driver, an old man, and a meek telephone repairman while preparing for the fight of his life. He is unaware that Suzuki is himself a martial arts expert who has doubled the odds by securing the services of a merciless Russian killing machine – the unstoppable Petrov (played by USA Karate Black Belt champion, Robert Baker). This was another first for the Chinese film industry. Bruce invited many stars of the karate world he had met and became friends with to Hong Kong. Bob Baker was one of these friends, a western star in a Chinese movie playing an Eastern Russian karate champion. The actual fight scene with Bob Baker was unlike the other action sequences – it was choreographed and directed by Bruce.

The fight scene is without doubt the highlight of the film for most fans. It is like watching a ballet,

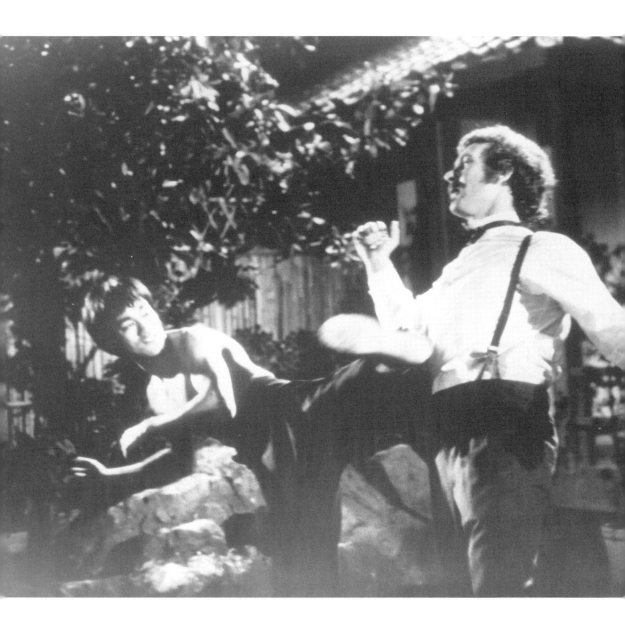

with tight controlled moves by both actors, good use of Bruce's facial expressions and of course his famous fighting cry – this was the film that introduced film-goers to Bruce Lee and his fighting *kiai*!

In one scene with Bob Baker, Bruce hits Bob at least eighteen times in a flurry of blows (which had to be slowed down for the camera). This was a new way to film fight scenes in close-up, with emphasis on facial expressions and hand-held camera angles. It worked sensationally!

The scenes that Bruce had control over were styled in the way he wanted the whole film to be directed. Bruce wanted to get away from the typical Chinese action film. He was not impressed by the film trickery or wire stunt performers of past films. He also had strong ideas on how his films should be more "westernised", with tight script and dialogue direction. Bruce also wanted to direct his own action scenes

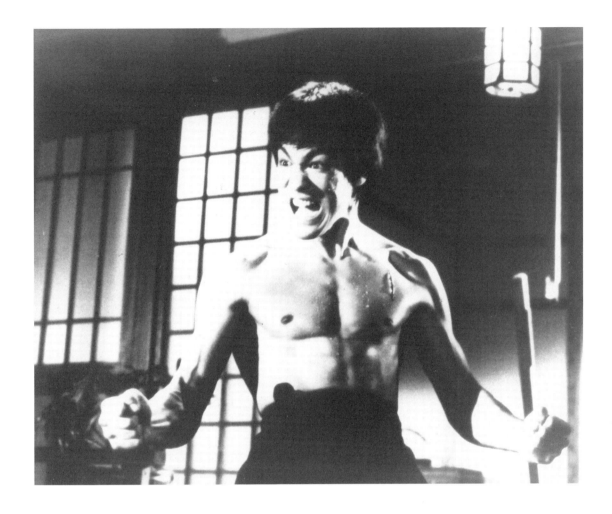

using ideas he had picked up in the United States, and using different camera angles. He was the first kung-fu action star to "kick" the camera as an opponent, giving the impression of being on the receiving end of his roundhouse back kick. He wanted to allow the camera to *become* the action, not just *film* the action. Everything Bruce wanted to arrange had to better than **The Big Boss**; the punches had to be faster, the kicks higher, the general effect more dramatic. The more perceptive fan will have noticed that he also began to take more notice of his acting skills, and he started to develop a sense of humour – and also his famous, arrogant trademark of "catching his nose with the side of his thumb before a fight".

Bruce had also noticed in **The Big Boss** and other films from Shaw studios, how the punching noise and "swish" of a fighting staff all sounded the same, generated on a machine by a studio technician.

Bruce started to take an interest in the swirl sound of the *nunchuka*, and how the sound of a punch to each section of the body had to sound different, and also be synced to the action as it happens. This can be found particularly in the scene with Bob Baker and Suzuki.

Fist Of Fury is a wonderful example of how Bruce had developed a sharpness for the camera in his many fight scenes. He can guess which way his opponent will turn, his responses are sudden, flexible

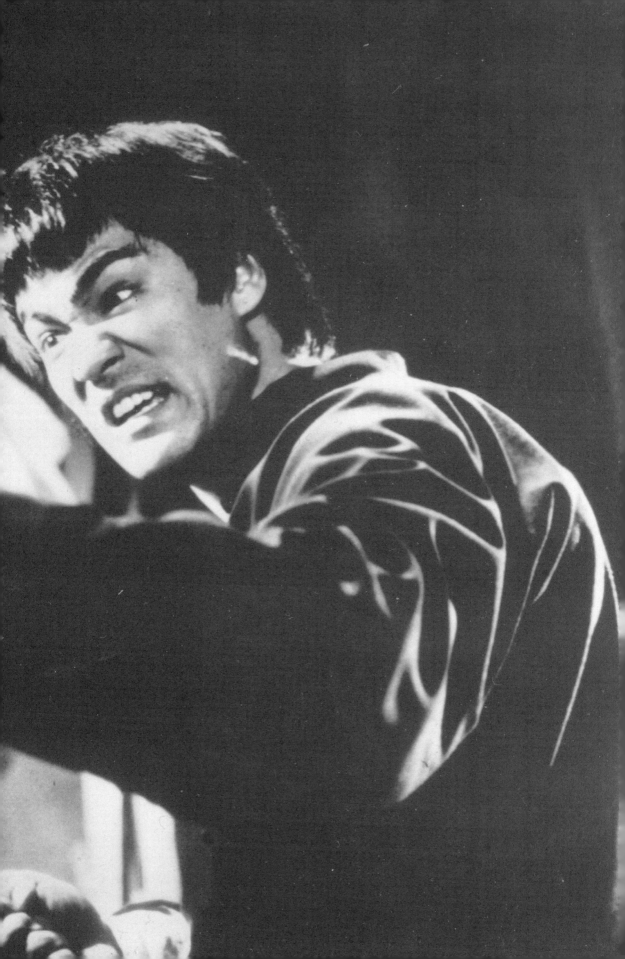

and controlled. This film also shows the lightning eight fast kicks, a sequence Bruce added to the film to show his kicking skill – he was not known as the "three legged" man for nothing in the fighting world of martial artists.

Bruce spent hours in the studio making sure that each frame sounded as well as looked good. Bruce wanted more control over his films, and he knew the only way around this was to develop his own company after the completion of **Fist Of Fury**, with Raymond Chow. The name of this company was Concord Films. While **Fist Of Fury** was being made Bruce was also giving technical direction to a film called **Unicorn Fist**. The fight scenes in this film were all directed by Bruce, and this is what makes the film stand out from the normal run of the mill Chinese film. The star of the film was Unicorn Chan – he was the Chinese waiter, Tony, in **Way Of The Dragon**.

By the end of the filming of **Fist Of Fury**, Bruce Lee and Lo Wei were barely on speaking terms. Bruce felt that the film was badly directed and the storyline made up along the way, as the director went from scene to scene.

This friction came to a head in the love scene in which Bruce played opposite Nora Miao. It is alleged that the director was listening to a horse race on his portable radio during the filming of this important scene (all voices were overdubbed in post-production). Bruce and Lo Wei had a furious argument and Bruce vowed never to work with the aging director again.

Bruce was not used to Lo Wei's manner of filming since he had been involved in direction of television shows in the United States, with proper dialogue and good action direction. Bruce wanted the same type of control over his projects; he eventually managed this, but it took a great deal of time and many enemies in the Chinese film world to achieve it.

The fight scenes in **Fist Of Fury** rank with the most impressive ever achieved on screen. This movie is a testament to Bruce Lee's incredible talents, as well as one of the most entertaining kung-fu thrillers ever made.

The end fight scene with Suzuki, after Bruce disposes of Bob Baker, is another example of Bruce Lee's mastery of the *nunchuka*. Bruce was heavily criticised for using the flails by some members of the media. But as Bruce stated in an interview just before his death, he was fighting a guy with a sword; bare hands would not have been much use against Japanese metal.

Incidentally, future star Jackie Chan appears in this scene; he was a stuntman in two films that Bruce made: **Fist Of Fury** and **Enter The Dragon**. In **Fist**, Jackie is first seen at the Chinese school playing a Japanese fighter. In his second scene, which is near the end of the film, Bruce kicks Suzuki through the bamboo panels. Suzuki was in fact played by Jackie Chan, who, as his stunt double, flew through the air and landed in the garden.

A scene Bruce would have preferred not to have had in the edited film was at the end of the fight near the beginning of the film when he picks up two Japanese fighters and spins with them, one at the end of each of his arms. He thought this unrealistic and also quite impossible.

Bruce was also not happy with, but accepted, the scene with the rickshaw and the Japanese

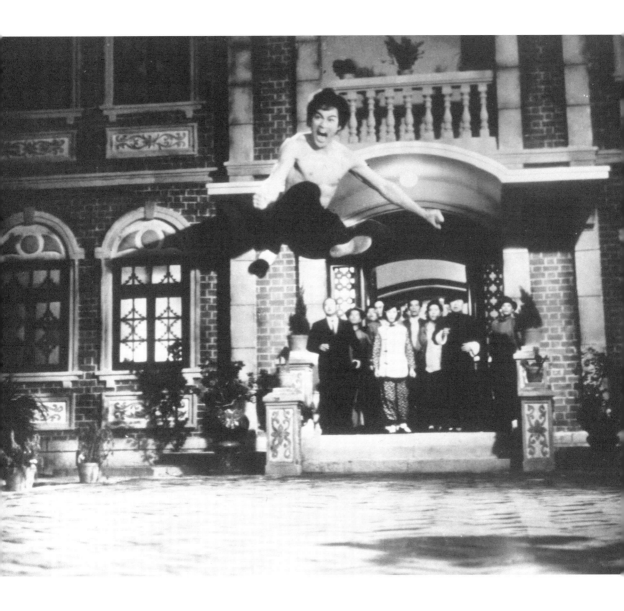

translator. The rickshaw was real, but Mr Wu wasn't; a light model was used for this effect. The arms of the carriage had been specially extended and just behind Bruce (but out of camera shot) were two helpers. Bruce accepted that no mortal man could lift this weight and decided that the film audience would also realise that this was not possible. Bruce hated the idea of film tricks.

Possibly the worst part of the film for fans is when Bruce gives himself up to the police and has to face the consequences of his actions. The last shot of him jumping to the camera, followed by an image freeze, is intensely memorable; the sound of gunfire ends the sequence. To make the point that crime and violence doesn't pay, Bruce Lee insisted that his character must die at the end – but die with honour. Lo Wei was unsure about this at the time, but agreed after another argument with Bruce, that this would happen.

Fist Of Fury sealed Bruce's success. Made for just $200,000, it grossed four million dollars in Asia alone. The film runs for approximately 1 hour and 46 minutes. The British Censor removed six minutes of footage for the 1973 release in the United Kingdom.

After **Fist Of Fury** was made and had premiered in the Far East, Bruce was a free agent. He did consider another Golden Harvest script, **The Yellow Faced Tiger**, but he wanted to rewrite the script and he certainly did not want Lo Wei to direct the film, after his handling of **Fist Of Fury**.

In summary, it has to be said that **Fist Of Fury** is probably the best film that Bruce Lee made, although it is felt that **Game Of Death** – which Bruce directed, produced and also wrote – would have excelled **Fist Of Fury** had it ever been completed. As it stands, many fans around the world feel even the 35-minute footage shot for **Game Of Death** (much of it censored for British release) to be the Master's best action work.

Fist Of Fury sums up Bruce Lee as a super-fit fighting machine who shows great emotion when confronted with being the underdog. If Bruce was alive today – and heading for his 60th birthday – he would surely still be proud to have been involved in this genre masterpiece of a film.

chapter three
"way of the dragon"

MENG LONG GUOJIANG (1972; US release title: **Return Of The Dragon**)
100 minutes
CAST: Bruce Lee (Tang Lung); Nora Miao (Chen Ching Hua); Chuck Norris (Kuda); Huang Chung Hsun (Uncle Wang); Chin Ti (Ah K'ung); Jon T. Benn (Boss); LiuYun (Ah Hung); Chu'eng Li (Ah Wei); "Little Unicorn" (Ah Jung); Robert Wall (Robert); Ch'eng Pin Chih (Ah Tung); Ho Pieh (Ah Ch'uan); Wei Ping Ao (Ho T'ai); Huang Jen Chih (Ch'ang Ku P'ing); Mali Sha (Blonde Lady).
CREDITS: Executive Producer: Raymond Chow; Associate Producers: Bruce Lee, Kuam Chih Chung, Chang-ying Peng; Director: Bruce Lee; Screenplay: Bruce Lee; Assistant Director: Chihyao Cha'ng; Cinematographer: Ho Lang Shang; Assistant Cinematographer: Laing Hsi Ming; Music: Ku Chia Hui; Editor: ChangYao Chang; Make-up: Hsieh Che Ming; Costume Designer: Chu Sheng Hsi; Sound Editor: Wang P'ing; Set DEsigner: Ch'ieng Hsin; Technical Direction and Martial Arts choreographer: Bruce Lee.

With the completion of **The Big Boss** and **Fist Of Fury**, Bruce Lee had finished his contract with Raymond Chow. Lee was free to do anything he wanted, but although he was tremendously popular with the Hong Kong audiences, Lee felt insecure with his success. It had been a long struggle to get to where he was now, and the bitter rejections he had suffered in Hollywood still haunted him. He knew that one false move could blow all of his success apart. There was talk of him appearing in another Golden Harvest production called **The Yellow Faced Tiger**, but Lee knew that his third film had to be something more special. He wanted to improve upon the success of his previous films whilst maintaining a respect to his own philosophy of kung-fu. The only way to do this, he felt, was to take a more active control over production duties. Now that his contract with Chow was completed, Lee was able to set himself an awesome challenge that would test all his skills and perhaps show off to those Hollywood executives exactly what he was capable of. He would star, direct, produce and write his own film, and also choreograph all the action scenes himself. Just to make the challenge that little bit harder, he would take a Chinese-speaking crew over to Rome and shoot on location for two weeks.

Way Of The Dragon began filming on 10th May, 1972, and Lee was by no means an easy director to work with. According to his wife, he could be very blunt and outspoken, making high demands of himself and everyone around him. He expected total commitment from all of his crew, pushing them through fourteen hour-long days. On location at the Rome airport, Lee and his crew shot sixty set-ups in one day alone. For the next twelve days they shot some rather standard travelogues to establish the city, a scene with Nora Miao next to the Trevi fountain, some shots setting up the climactic fight at the Coliseum, and a graveyard scene that would close the picture.

Once location shooting was complete, Lee returned with the crew back to Hong Kong ready to shoot all the interior scenes and the fights. His attention to detail over the fight scenes meant they took a long time to film. Lee would watch the rushes each night, and if a particular punch or kick didn't quite connect, he would reshoot the next day. After studying so many different fights, from Ali's confrontation with George Foreman right the way down to film footage of junior karate competitions, Lee used all these as inspiration to create a structure for his final duel with Chuck Norris. He wrote nearly a quarter of the script – twenty pages – describing in exact detail how the fight would be staged, choreographed and shot. On set, he would take six days to shoot the scene. Even though Lee may have been difficult to work with, he was always a perfectionist and he always knew exactly what he wanted. If we consider that Lee trained his mind in philosophy, his body in martial arts, and was so undisputedly dedicated to both and ambitious enough, we can certainly be sure that he was just as educated in film directing. **Way Of The Dragon** is an assured debut for a first time director, with some very accomplished and exhilarating fight sequences.

KUNG-FU LANDS IN ITALY

We open on a close up of Lee's face, emotionless and meditative. The corners of his mouth flicker, his nose twitches and we zoom back. We see an American lady standing next to him, studying him like a zoo exhibit as if it's the first time she's ever seen a Chinese man in a black silk suit. Instantly we warm to his country bumpkin character Tang Lung as he begins to feel self-conscious and rather uncomfortable, especially as his hungry stomach starts to moan. He tries to mute the sound of his stomach rumbling by covering himself with his bag. He tries his best to smile apologetically to the American lady, but she still watches him like he's a bear in a circus. As soon as she leaves, Tang relaxes and breathes a sigh of relief. It's a very funny scene for Lee to open his film, but he sets up in a very short space of time that here is a stranger in another country, unable to understand the language or the customs. There's no dialogue to tell us these details, we are given our information through visuals alone. In fact, for the first ten minutes, we may as well be watching a silent comedy by Jacques Tati. Sound effects are exaggerated for comic effect and the observational humour is based on the conflict between Lee's naïve simpleton and Rome's apparent modernity.

The comedy continues when Tang goes to a restaurant and orders a plate of eggs. He can't understand anything written on the menu, but feeling pressured to order something quickly, he points at something that looks about right. The waitress returns with a tray carrying six bowls of soup. Tang hides his embarrassment with a look that says "it's exactly what I wanted anyway", and puts his napkin on à la Stan Laurel. He digs into the soups quickly, getting them down as soon as possible so he can get out of the restaurant. Outside, he meets up with Chen Ching Hua (played by Nora Miao). First impressions for Chen are not good when Tang, suffering silently after too much soup, asks for the toilet.

"ARE YOU LOOKING AT ME?"

Chen drives Tang around the town, and as she tells him of her difficulties at the restaurant and the American boss who wants to buy her out, we are shown travelogue images of the city. Back at Chen's

place, Tang needs to use the toilet once again. Whilst Tang is away, we see that Chen is beginning to lose hope. She anticipated that Tang would be able to help, but he seems too foolish and naïve to European manners. By the Trevi fountain, Chen teaches Tang that Europeans are a lot different to Chinese people, and that when somebody looks at you, you look back. If they put their arm around your shoulder, you do the same. Meanwhile, whilst Chen is telling him all of this, Tang has unwittingly picked up a prostitute.

Tang returns to the prostitute's house. He stands alone in her bedroom, just looking around when he is startled by his own reflection in a mirror. He regards himself, looks at the bags under his eyes, then practices a few moves. It's a moment that is reminiscent of Travis Bickle in **Taxi Driver**, and at once it seems narcissistic. Tang is taking pride in his body, in his abilities, but more than that so are we. For the first time in the film, the audience are allowed to admire Lee's skills. He prowls and snarls then leaps into a few kicks, but just before he gets too involved in his warm ups, the prostitute returns in the doorway. Tang's narcissism is conflicted with a satisfyingly gratuitous nude shot of the prostitute. He looks at her naked body and, suddenly realising the situation he's got himself into, he runs away.

CHINESE KUNG-FU VS. JAPANESE KARATE

Tang is greeted at Chen's restaurant by the chef, Uncle Wang. He tells Tang that the rest of the boys are upstairs on the roof practising their martial arts. The waiters have nothing to do since the American thugs have scared away all the custom, so they spend their free time training in karate. Tang introduces himself as somebody who "knows a little about Chinese boxing", and the boys egg him on to demonstrate his abilities. Tang shows reluctance, but we know that deep inside him is a lot of energy waiting to burst out. Three of the waiters surround Tang with punch pads, and there is a certain amount of suspense as we wait for Tang to strike. Just as we think he's about to start, Uncle Wang interrupts the scene and tells the boys that there are customers downstairs that need serving.

Like in **The Big Boss**, tension is built up as we anticipate Bruce Lee's first fight. Whether the interruption be a naked prostitute or Uncle Wang telling the boys there are customers, we are only treated to the sight of Lee warming up, getting ready to fight, showing off to himself in the mirror or showing off to the boys on the roof. This tension is further protracted when the American thugs enter the restaurant and kick out the customers. Whilst the waiters are warned back by Uncle Wang not to get involved, Tang's opportunity to become the hero is wasted as he spends another visit to the toilet. On his way out of the bathroom, Tang bumps into the American boss' second in command. Ho is an over-the-top, very camp Chinese man who takes an instant shine to Tang's athleticism. He prods and pokes Tang's abdomen, revelling in its hard muscle. Tang just smiles back, oblivious to what Ho and his thugs have just done to business. After Ho leaves, Chen and the waiters turn their back on Tang, but Uncle reassures him that everything will be alright.

Later, and the waiters are boasting about their karate skills. One of the boys says he could have knocked out those thugs with one karate punch. They all nod in agreement, then look over to Tang who sits on his own. The waiters laugh, "at least it's better than Chinese boxing!" At that moment, the thugs return. Rather than mess up his restaurant, Uncle Wang orders them to take their fight upstairs. On the

roof, the waiters line up on one side and the thugs line up on the other, ready for the first confrontation.

Now this is a fantastically directed sequence and really has to be concentrated in detail. The colours, the set-ups and the choreography make this fight scene look more like a musical number. Chen stands next to the waiters who are lined up like soldiers, all wearing lush red suits. Uncle Wang is in his white chef's uniform and Tang is dressed in his usual black silk. Opposite them are the variously dressed Americans in t-shirts and jeans. The first waiter, Jimmy, steps forward to confront the burly American. The American knocks him out with one punch. Another of the waiters, Tony, steps forward, but Tang stops him. "Let's show him Chinese boxing". A timpani drum booms on the soundtrack and now the audience knows for certain that Lee is about to fight.

To the sound of timpani and cymbals, Tang dances through some peacock style movements before adopting his fighting stance. The American just yawns, sniffs and raises his fists. Meanwhile, the waiters watch and anticipate – Chen resignedly shakes her head. We cut to an extreme close up of Tang's face, then a quick zoom back to a medium long shot to take in his first kick. Thwack! Cut to medium close up of Tang: "Movement number four. Little Dragon finds its path". A medium long shot for the second kick, then a quick zoom to close up on Tang's face: "Big Dragon whips its tail". The zoom out and zoom in emphasise that the power of the kick comes directly from the eyes.

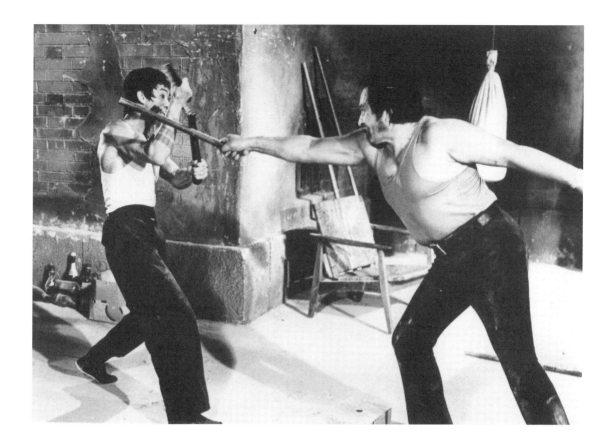

Tang glances over at the rest of the Americans. They stand there looking at Tang, then look down at the floored fat guy. Meanwhile, the crowd shot of the waiters tracks in to a close up of Chen who is suddenly impressed. With this close up, the point of view of the scene changes and we can see her perspective of Tang. The three Americans left over get ready to fight and one steps forward. Tang unfolds his arms, pouts and wiggles his hips before delivering a supercharged blow. After flooring this second guy, Tang arrogantly sits on his chest. The remaining two Americans step forward. We track forward towards Tang, watching the thugs approaching through his cooler-than-ice eyes. Another cutaway of Chen's impressed face leads to a point of view shot as Tang takes out both Americans from a sitting position. Now that all four Americans have been knocked out, Tang looks around him before he sniffs, rubs his nose and shrugs casually that he was only doing his job.

For a fight scene, it's economically shot and every set-up has been carefully thought out beforehand. The fight is allowed to develop naturally, the kicks are full of emotion and sound, and there is even an opportunity for Lee to teach some of his moves. The scene is given added depth with Chen's sub-plot as she wakes up to Tang's talent. Although the zoom in and zoom out shots sound perfunctory, they are incredibly difficult to time. Even if the sound is post-dubbed, Lee has to work in tandem with his cameraman to get it all timed to perfection. The use of close-up to show the intensity of Lee's kick works superbly. The importance of these close-ups conflicting with the long shot also works in a later scene when

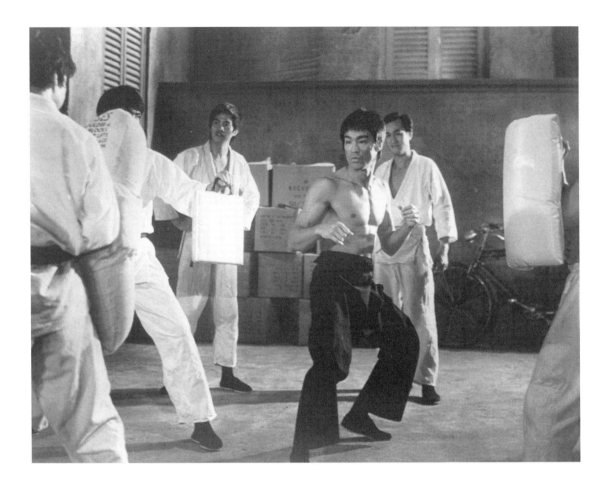

Tang demonstrates his abilities with the waiters. Tang squares up to a volunteer holding up a punch bag. In long shot, the kick fails. Tang draws back for a second attempt. We cut to a low angle close-up as Tang concentrates on the opponent instead of the bag. He goes for the kick, and in slow motion the opponent flies backwards into a wall of cardboard boxes.

THE BODY VS. THE BIG BOSS

On returning to the flat, Tang and Chen are faced by another of the thugs, this time pointing a gun. Tang quickly disarms him with a wooden dart that he throws from his sleeve, before moving in to give the American a damn good kicking. When the thug reports back to the boss, he is in a rage. "How can one man defeat so many?" Ho, his second-in-command, tries to explain. The boss can't believe his ears. "kung-fu?"

Cut to Tang on the balcony back at the flat, training his body and hearing his muscles and bones click into place. The sounds are exaggerated with timpani and clicks on the soundtrack. Once again, as like a motif through all of Lee's films, he is stripped to the waist. For a moment, his attention is distracted and he investigates a smell, only to be further distracted by a picture of a naked couple in an embrace. Tang turns away, puts his hands together in silent meditation, then leaves the prayer with a lightning quick

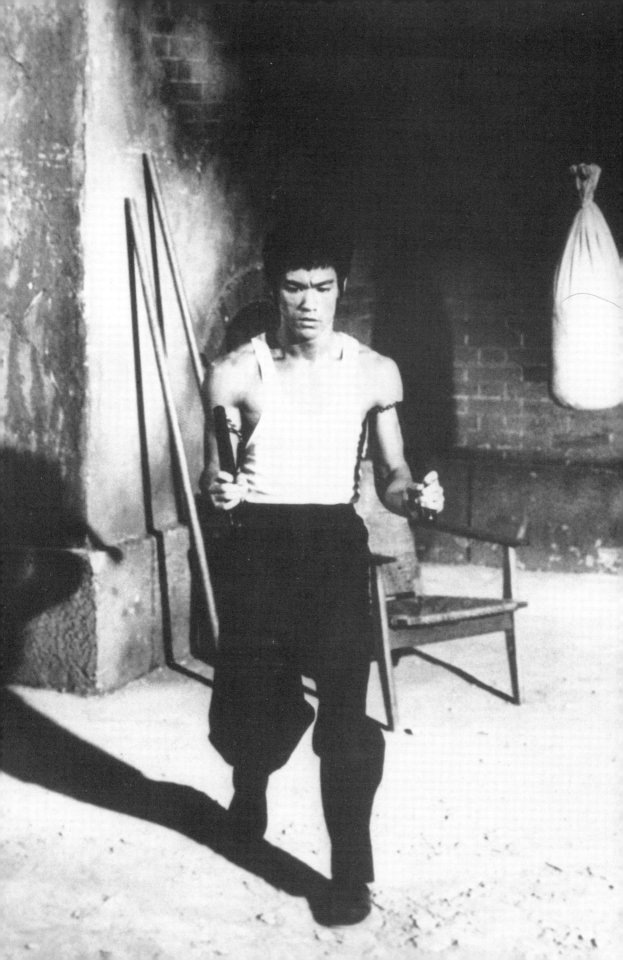

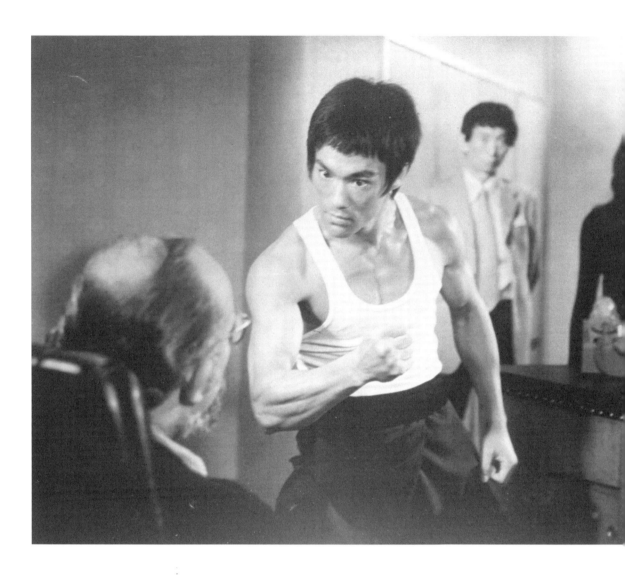

punch. It's as if Lee is directing all of his energy in one direction only. The character of Tang is sexually naïve – that was set-up from the start with the prostitute scene – but now we understand that with discipline, the mind can overcome temptation. The narcissism mentioned before is mirrored in this short scene and emphasised with a self-deprecating irony. Whilst Bruce Lee may not be the world's most physically perfect specimen, he's pretty damn close.

The American boss ambushes Tang at the restaurant, and this time all the thugs have got guns. Tang is taken to the roof where he is to be shot, but instead he easily dispatches the three guys that surround him. It's at this point in the film that Lee gets out his *nunchuka* weaponry and a major fight sequence ensues. Unfortunately, in the UK version of any kung-fu movie, references to the *nunchuka* must be edited out. In the case of **Way Of The Dragon**, there's about five minutes cut out of there in a scene which even the usually disparaging *Variety* magazine opined as "very impressive". One minute, the restaurant is full of thugs. Tang has already wasted the guys on the roof and somehow, in the time between

the next cut, he's disabled all the guys downstairs and is telling the big boss to leave. Watching the film without the *nunchuka* scene is like watching the musical "Oklahoma!" without the title song. I don't think this is what Eisenstein meant when he said that a film story should be told in between cuts. All I can say is that in this age of Internet shopping, there has to be a better version available somewhere.

Leaving that issue aside and going back to the story, the boss kidnaps Chen whilst Tang chases a gun-man from a nearby rooftop. The language barrier prevents Tang from calling the police, so he has to take the fight on his own. It's at this point that we find out that Lee, the director, is seemingly a big fan of the Spaghetti Western. On entering the boss' office, Tang whistles an Ennio Morricone theme. The thugs reach for their guns, but Tang disables them all with his wooden darts. A big punch-up flares. Now in most punch-up scenes involving Lee, he will always stand back and watch the others take up the fight. He doesn't run in there straight away, he lets the others have their turn first. Lee will only get involved if one of the thugs leave the fray and accidentally land a punch. When Tang is distracted for one second and fails to see a punch come his way, he gets really racked off. Once again, we zoom into his face as four thugs circle him. A quick zoom back and Tang starts his action. He beats them all. A rather weedy-looking American squares up to him, but Tang just waves for him to go home. The American squares up again. Tang takes a step backwards. We cut to a medium long shot of Tang jumping up high and kicking a glass lampshade. It's an absolutely stunning shot. The weedy American takes another look at Tang and wisely decides to beat the retreat.

Tang squares up to the big boss after pushing him down to his seat. To get over the language barrier and the message that the boss should leave them alone, he talks with his body language. Tang points at the boss, thumbs at the girl, wags his finger, clicks the knuckles on his fist, then points one fist at the boss. Tang raises his eyes as if to say, "do you understand?" The boss nods his head quickly. Tang sniffs and steps back.

BRUCE LEE AS THESEUS, CHUCK NORRIS AS THE MINOTAUR

Ho tells the boss to enlist the help of an American karate champion called Colt, played by Chuck Norris. Now, Chuck Norris' name has been unfortunately associated with too many Golan-Globus productions, so it's sometimes forgotten that he used to be the US master of karate. In fact, he held on to this title for seven years before **Way Of The Dragon** came along. For Norris, this was to be his motion picture debut. In a film that is very anti-American, we just know that the final fight sequence is going to be excellent. When Colt arrives at the airport, a Morricone twangy guitar is accompanied by Chinese drums. He walks towards the screen, leading to an extreme close-up of his groin. We can hear the balls on this guy.

The build-up to the final confrontation is beautifully cinematic. Tang enters the Coliseum and finds Colt standing at the top on a balcony. Colt raises his thumb like a Roman emperor, then turns it down. Tang shrugs him off. Meanwhile, the grating echo of Ho's high voice reverberates around the ruins. "Tang Lung, the man you've just seen will kill you." Tang begins his search for Colt through the labyrinth. The tension becomes unbearable as every exit for Tang is closed and Colt stalks him from above. "Tang Lung, you will soon be a dead man." Ho's laugh wears our patience thin. A cat jumps out at Tang and gives

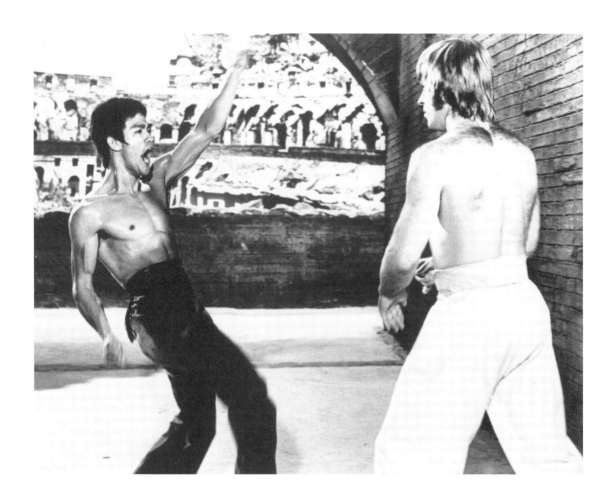

him a temporary jolt. Finally, Tang finds his opponent. Colt stands legs apart like Henry Fonda in **Once Upon A Time In The West**, and Tang is framed a tiny figure in between. The Morricone-style theme plays throughout.

Perhaps the most refreshing part of the kung-fu sequence to follow is its complete respect for martial arts. Tang and Colt don't fly at each other with fists raging. Instead, the action is delayed. Both opponents regard each other like lovers, they disrobe like a couple about to have sex. Once they have both stripped to the waist, they turn away and prepare themselves with a few warm-up exercises. Colt shakes his head, stretches his arms and tries a few shadow kicks. Tang clicks his knuckles, rolls his shoulders and hugs his knees. Finally, both men approach each other and adopt their first stance.

Tang attacks and pushes Colt back, but Colt returns with a swinging kick. Tang retaliates, but Colt is too quick and strikes a few blows at Tang's face and chest. Colt twists him to the floor and goes for the kill, but Tang blocks his fist and grabs hold onto Colt's chest hair. The pain for Colt is extreme, but he rips himself away. Tang blows the chest hair from his hand. Colt brushes himself down and Tang sees a chance. He strikes forward again, but Colt deflects him and pushes Tang to the floor with a windmill kick. Colt wags his finger at Tang as if to say, "don't ever do that again." Tang realises he has met a match.

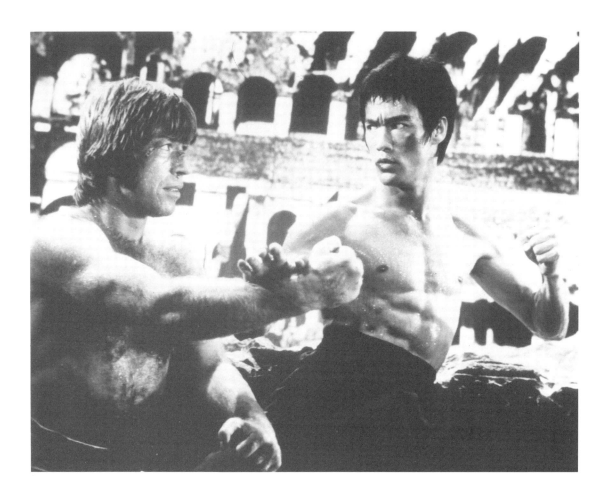

Tang stands up, hops from foot to foot on the spot, and the camera zooms up once to a medium shot, then a second time towards a close-up. Tang decides to quicken the pace. Like Ali against Foreman at the Rumble in the Jungle, Tang dances around Colt and lets him punch himself tired. Colt catches on to Tang's tactic and stops the fight dead.

For the next section of the fight, Tang wins on points for each swap of blows. Colt eventually feels himself getting tired out. Through his blurred image he can see Tang snarling, hopping from foot to foot. Seeing his opponent sweat is enough for Tang to regain his focus and control. As Colt gets up, he flattens him again. When he gets up again, Tang staples him to the wall with a series of blows. Colt tries to punch back but Tang grabs and twists his arm out of place before breaking his leg with a downward kick.

Tang steps back to stop the fight but Colt wants to carry on to the end. He knows he can't win, but his warrior code demands death or glory. He staggers around before finally getting himself upright, then he charges forward with a misplaced punch. Tang wraps his arm around Colt's neck and breaks it in one sudden movement. We close in on Tang's anguished face – he has reluctantly taken another man's life. In a last act of respect, Tang gathers up Colt's jacket and black belt before covering his dead body.

"BIG DRAGON WHIPS ITS TAIL"

Lee never intended to release the film in the West. **Way Of The Dragon** was made primarily for a Chinese audience, and Lee constructed a story with their tastes in mind. The humour in the first half of the film may seem hackneyed to Western eyes, but Chinese audiences lapped it up. This was perfect for Lee, who wanted to show a more sensitive side to his character that he was unable to show in his previous films. Chinese audiences also enjoy seeing their heroes defeat people of a different race. When Colt appeared and the final death match was screened, the audiences cheered to see Tang defeat an American karate champion. The film's success in Hong Kong was well assured, and Lee had a well publicised bet with his critics in the press that the film would earn $5 million, outgrossing his previous films. Lee won.

Lee had proved to himself and to others around him that he was an accomplished and successful director, but he was by no means a master. There are flaws and inconsistencies in the story, but these are more than made up by the terrific fight sequences. There is a particular problem though when Uncle Wang kills two of his nephews and reveals himself to be in league with the American boss. It's a strange and unexpected twist in the story, and clumsily told. The only necessary reason one can think of that there should be this scene is that it's the only death so far in the film. Considering it directly precedes the Coliseum showdown, then the balance of the story has to be right before the hero can go on to kill the villain. Maybe this is the key to why Tang looks so remorseful after he has taken Colt's life.

Throwing all these inconsistencies aside, any director would be proud to call this their first movie, and had he lived, Lee would have developed his talents further and displayed them with more confidence. There's no doubt he would have been as successful a director as he was a martial artist. His testament though is that he paved the way for future directors like Jackie Chan and Sammo Hung, both directors with a passion for martial arts and a similar understanding of comic timing. We can only imagine the successes Lee could have achieved had he lived, but this knowledge is just another part of what makes him an enduring legend.

chapter four

"enter the dragon"

ENTER THE DRAGON (1973; Hong Kong release title: **Long zheng hu dou**)
98 minutes (25th anniversary edition: 110 minutes)
<u>CAST:</u> Bruce Lee (Lee); John Saxon (Roper); Ahna Capri (Tania); Bob Wall (Oharra); Shih Kien (Han); Angela Mao Ying (Su-Lin); Betty Chung (Mei Ling); Geoffrey Weeks (Braithwaite); Yang Sze (Bolo); Peter Archer (Parsons); Jim Kelly (Williams).
<u>CREDITS:</u> Producers: Fred Weintraub, Paul Heller in association with Raymond Chow; Director: Robert Clouse; Screenplay: Michael Allin; Cinematographer: Gilbert Hubbs; Editors: Kurt Hirshier, Geo. Watters; Fight Sequences: Bruce Lee; Music: Lab Schifrmn; Costume Designer: Louis Sheng; Make-up: Sheung Sun, John Hung.

In 1969, Bruce Lee conceived "The Silent Flute", a semi-supernatural story about an individual martial artist's troubled journey towards self-knowledge. Although *The Green Hornet* TV series and minor detective flick **Marlowe** had raised his US profile, Lee was realistic about his chances of convincing a major studio to trust him with a lead. He approached Steve McQueen to star as Cord, "the seeker". But McQueen took a prickly view of the project, worrying that Lee was trying to use him as a vehicle to further his own screen career. Instead, Lee and **Towering Inferno** screenwriter Stirling Silliphant turned to James Coburn, who agreed to play the lead.

With Coburn on-board, Warner Bros. expressed an interest, with a finance-led proviso that the film be shot in India. The three men flew to Bombay on a month-long location hunt. Practical problems compounded tensions between Lee and Coburn, who eventually withdrew, taking Warners with him. (**The Silent Flute** [aka **Circle Of Iron**] eventually appeared in 1978, starring David Carradine and directed by Richard Moore. Lee and Coburn were jointly credited with the storyline.)

In 1972, with three Hong Kong-produced films behind him, Lee was busy shooting initial fight footage for another – **Game Of Death** – when Warners finally came round to the possibility of "breaking him" in America. On the back of Nixon's recent visit to China, US interest in Asian culture was growing and Warners head of Asian distribution, Richard Ma, talked up the possibility of Lee as the credible anchor for the first uniquely Hollywood-produced martial arts film. With a TV pilot-sized budget, Ma appointed Fred Weintraub and Paul Heller as co-producers. Although the suits at Warners remained relatively sceptical, Weintraub, who had originally told Lee to conquer Hong Kong before trying to get noticed in Hollywood, was the key. He brought in screenwriter Mike Allin, who wrote a story called "Blood And Steel". Weintraub flew to Hong Kong and, after initial slipperiness from Raymond Chow, sealed a co-financing deal with Chow and Lee's production company, Concord.

Lee suspended work on **Game Of Death** and, after insisting on a name change, **Enter The Dragon** began pre-production in Hong Kong, in early 1973. Ex-CBS stills photographer Robert Clouse was brought in as director. Clouse had impressed with Academy Award nominations for two of his short films and, in his own book on Bruce Lee, Clouse's conceited implication is that he was chosen because Lee was familiar with his work. Weintraub's version is that nobody else wanted the job. The omens were murky: dubious studio backing, low budget, low pay, an untried director...

Over in Hong Kong, Lee made an attempt to acclimatise Clouse by taking him to a screening of **Way Of The Dragon**. The rest of the cast (including John Saxon and karate champs Jim Kelly and Bob Wall) arrived, and production began.

In **Enter The Dragon**, Lee is imaginatively known as "Mr Lee", the star student at a Shaolin temple in rural Hong Kong. He receives a visit from a British intelligence agent, Braithwaite (Geoffrey Weeks), who proposes his mission: to expose the illegal operations of classic Bond-style bad guy Mr Han, by entering a martial arts tournament held on Han's private island off the Hong Kong coast. During the meeting with Braithwate, Lee attends to an eager, but unformed student, encouraging him to attack with "emotional content, not anger" and dropping in some homespun *jeet kune do* philosophy ("It is like a finger pointing away to the moon. Don't concentrate on the finger or you will miss all the heavenly glory"). The credit sequence shows Roper (Saxon) and Williams (Kelly) arriving in Hong Kong.

Braithwaite shows Lee a series of slides featuring Han and his entourage, noting, crucially, that Han is a renegade of the Shaolin temple. We learn that the tournament, held every three years, is a front for Han's mini-industry in drugs and prostitution. Braithwaite stresses that Han's fear of assassination has rendered the island gun-free ("Any bloody fool can pull a trigger"). It's revealed that a female operative, Mei Ling, is already in place.

After a flashback sequence featuring Lee's sister, who commits suicide rather than be raped by Han's bodyguard Oharra (Wall) and his men, Lee visits his father's grave and expresses regret for "what I am about to do".

Two following flashbacks deal with Roper and Williams' path to the tournament: Roper is after winnings to pay murderous debtors back in the US, while Williams is on the run after beating up a pair of redneck cops outside his karate school. On the main boat to the island, the two Nam buddies meet again.

During the journey, Roper loses a bet to Lee on a praying mantis fight. Later, a belligerent co-traveller Parsons (Peter Archer) abuses the crew and tries to menace Lee into showing him some of his "style" ("the art of fighting without fighting"). Parsons is tricked onto a small rowing boat. Lee untethers the boat and hands its control over to a group of crewmen for sport.

At the island, the entrants are shown to their rooms by Han's chief female attendant Tania (Ahna Capri). On their way, they pass hordes of Han's men, training – in, it has to be said, a rather feeble fashion – in karate. There's a lascivious evening welcoming party, with sumo wrestlers and Chinese-style banquet. Han arrives and welcomes the competitors while his bodyguard daughters perform tricks with throwing darts and apples.

Tania parades a selection of the island's women around the rooms of the competitors. Williams comes over all Jimi Hendrix and selects three ("If I've missed anyone, I'm sorry. You have to understand – it's been a long day. I'm a little tired"). Roper chooses Tania herself, and Lee asks to see the woman he recognises as agent Mei Ling (Betty Chung). She arrives, and Ling confirms what she's seen of Han's shady dealings, telling Lee that he has to act fast because many of the woman have "disappeared" and she's beginning to fear for her own life.

In the morning, Lee's training is interrupted by Oharra who warns him that he must attend the day's ritual in uniform. He doesn't. Roper fights and beats Parsons. In the crowd, Williams bets with a fellow onlooker, signalling Roper to begin his next fight badly. When the odds are suitably against him, Roper wins convincingly (Saxon was a real-life student of Lee's). Later, Williams leaves his designated woman to nip out for a stroll, despite her warnings that "it is forbidden". At the same time, Lee slips out,

stealthily downing two guards and sneaking a look at an underground facility. On his return, Williams catches sight of Lee.

The next day, Han expresses his anger at the unknown intruder and orders a hulking enforcer, Bolo (Bolo Yeung) to beat his incompetent guards to death. (Han: "Are you shocked, Mr Williams?" Williams: "Only at how sloppy your man was.") Lee squares up to Oharra, who turns on the intimidation by shattering a wooden board in front of his face (Lee: "Boards don't hit back.") They fight. Lee initially wears him down with two venomous *jeet kune do* jab-punches. Clouse claimed he had to slow this sequence down in order for the strikes to sufficiently register on film. Lee side-kicks Oharra into the crowd, where he grabs and smashes two bottles and attacks. Lee disarms him and pounds him out cold, finishing with a death-blow. After showing his dismay at Oharra's dishonour, Han leaves.

Williams is summoned to see Han, who accuses him of being the previous night's intruder. Strapping on a prosthetic iron hand, Han fights Williams, eventually beating him to death in a psychedelic back-room filled with wasted, giggling girls. Later, Han (complete with archetypal fluffy cat) shows Roper around, revealing the extent of his drugs/prostitution industry and attempting to recruit him as a US contact. Han tests Roper's outlook by presenting Williams' body, impaled on a hook, dropped into a vat of acid. Understandably, Roper is appalled and declines the offer.

Lee infiltrates the base (making innovative use of a guard cobra), finds the radio room and sends

out a message for Braithwaite. But he trips the alarm, and streams of Han's henchmen come running. In arguably the most impressive, perfectly realised fight sequence of Lee's career, he battles the seemingly endless hordes with fist, foot, pole, *kali* sticks and (unless you're watching in the UK) *nunchaka*. Eventually, he's sealed off by some convenient sliding metal doors and captured by Han ("Your skill is extraordinary. I was going to ask you to join us...")

In the morning, Han tries to force Lee and Roper into a fight to the death, but Roper refuses, fighting and defeating Bolo instead. Meanwhile, Mei Ling releases Han's prisoners who pour outside to join Lee and Roper in a mass battle with his followers. Han screws in a metal claw prosthetic and scurries away, pursued by Lee. Inside, they meet (Lee: "You have offended my family and you have offended the Shaolin temple"). In combat, Han realises that he's no match for Lee and, after landing a couple of swipes with the claw, reverts to using a spear which eventually becomes embedded in a revolving wall. He escapes into a room constructed from multiple mirrors. Lee follows and, in a heavily stylised set-piece, shatters all the mirrors to separate Han's reflection from reality, eventually side-kicking him onto his own spear. Outside, the cavalry finally arrive and Lee offers Roper a weary thumbs-up.

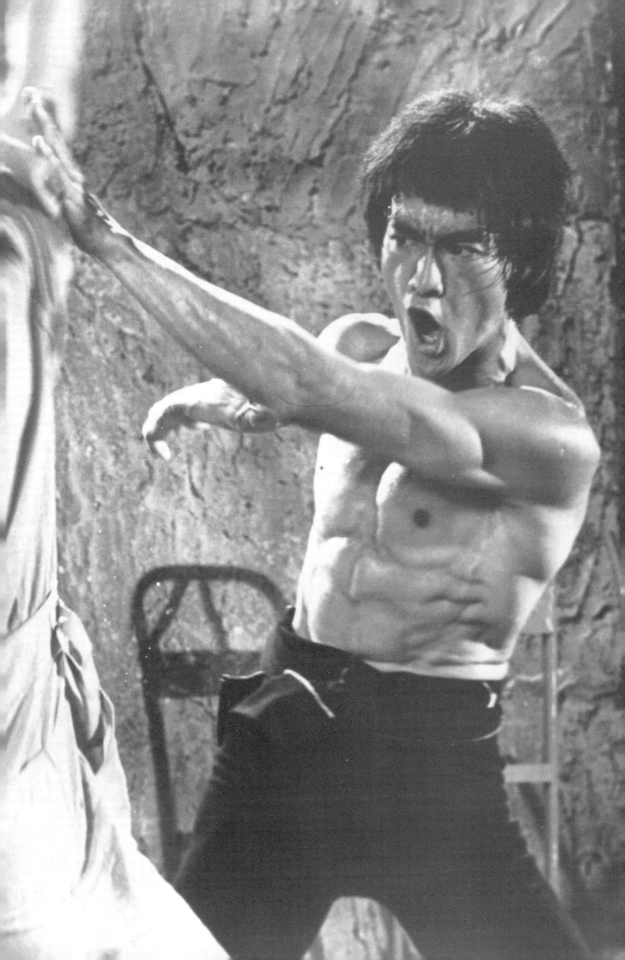

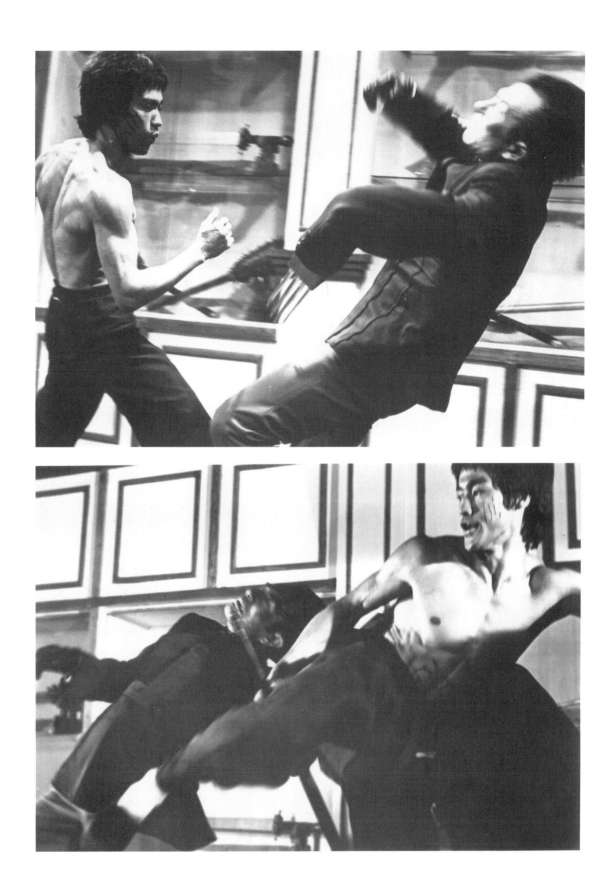

Despite the undeniable slickness of the end product, the shoot was a nightmare. Lee was worried that his heavily westernised character would appear "sold-out" to loyal Chinese audiences used to him as a low-key outsider battling a more street-level brand of injustice. Clouse claims that initial artistic spats with Allin led to the screenwriter churlishly adding letter "r"s to Lee's dialogue, knowing that he would find them difficult to pronounce. Exasperated, Lee demanded that Allin be replaced – which was agreed. But a few days later, Lee, under the impression that Allin had been sent home, ran into him on a Hong Kong ferry.

On-set, the bad feeling wasn't exactly vanquished by smooth operations. Separate American and Chinese crews mounted constant communication challenges, compounded by a lack of foresight in hiring an adequate number of interpretors. Worse, when mistakes were made, many of the proud Chinese crew members simply couldn't bring themselves to turn up again. It was an oddly arrogant attempt at a straight port-over of Hollywood's methods into a Chinese film-making environment and the chaos was evident before filming even began, with cheap Chinese workmen being hired to bang together sets from improvised materials.

Higher up, persistent power-jockeying dominated the production. Chow had taken it upon himself to act as creative overlord, alienating Lee who felt that, without him, the film wouldn't have even been green-lighted. He walked off the set and, after two weeks of being bombarded by revised scripts and increasingly desperate calls from Warners, finally returned two weeks later. In his absence, filming had

begun – with specially flown-in praying mantises initially refusing to fight, while extras from rival Triad "families" were only too happy to oblige.

Lee began filming under immense psychological pressure, well aware he had finally been given the chance to speak to a much wider audience and entirely at the mercy of his own fastidious fight choreography. The complex multiple-attack scenes in the underground base often ran to more than twenty takes and, in the withering humidity, he was losing a lot of weight and suffering from dehydration. His relationship with the director was also shaky. In public, Clouse expressed admiration for Lee, but, according to Bob Wall, the thin dressing-room walls often filtered through his true feelings about the star: that he couldn't act, couldn't even speak properly. Lee retaliated by barring Clouse from the set during his fight scenes, insisting on directing them himself.

Meanwhile, the on-set logistical slapstick intensified. Props and lighting set-ups were constantly switched around, causing tiresome and expensive reshoots. The scheduled banquet scene was initially without a vital ingredient: food. First cameraman Gil Hubbs was mortified at the state of the Golden Harvest camera equipment and was forced to hire his own, adding to costs and producer-technician tension. Most astonishingly, Han's "drunken old men who no longer care where they are" prisoners were all actual Hong Kong vagrants, and the island's sirens-for-hire were real prostitutes who demanded higher wages than the cameramen and many of the actors.

Safety was barely an issue: sound stages littered with squatters, erratic electrical supplies, scalding arc lamps boosting the unventilated heat to intolerable levels. In the scene where Lee tricks Parsons into the rowing boat, Peter Archer almost drowned when the boat capsized. Lee himself needed twelve stitches on a hand wound after he accidentally clipped one of the bottles smashed by Oharra (normally, specialist bottles made from sugar would be used – these were real). He was also bitten by the cobra his character uses to flush out a guard in the radio room. Miraculously, someone had remembered to drain the cobra of its venom beforehand.

The point of such a spit-and-polish approach, according to Clouse, was to retain an authentic location atmosphere which would have been difficult to fake on a polished Hollywood sound stage. But the experience had drained the heavily westernised Lee, who now prepared to move back to California and rethink his approach to **Game Of Death**.

During dialogue-dubbing at the Golden Harvest studios, he complained of faintness and collapsed into a seizure-like fit of vomiting and hyperventilation. Noting a swelling of fluid on Lee's brain, neurosurgeon Dr Peter Wu administered Manitol, a radical dehydrating agent, which succeeded in reducing the swelling. After a short stay in hospital, Lee recovered and returned to his family in Los Angeles, where, following extensive neurological tests, he was prescribed the epilepsy drug Dilantin.

Eventually, Lee finished the dialogue recording in Los Angeles, and a rough cut was screened to ecstatic Warners execs who authorised an extra $50,000 to polish up the soundtrack. As Warners booked Hollywood's fabled Mann's Chinese Cinema for an August première, Lee embarked on the promotional rounds and began discussions with Warners on a future five-film deal.

Back in Hong Kong, Lee tried to avert his attention back to **Game Of Death**, but his exposure had reached critical mass. Alongside a further souring of his relationship with Raymond Chow and Golden Harvest, he was finding everyday life increasingly difficult and intrusive. Mobbed in public and suffering from insomnia, he developed a mighty thirst for *sake*, and turned to chewing cannabis to relax. He became paranoid and isolated, developing a pessimism about the future; fearing that the current obsession with martial arts movies could only hold for a few years. Friends began to notice an Alzheimer's-like tendency for Lee to repeat himself. He began a relationship with actress Betty Ting Pei and, on the night of July 20th, 1973, collapsed at her Hong Kong apartment and was pronounced dead at the Queen Elizabeth Hospital hours later. Despite the inevitable wild conspiracy theories, the inquest stated the official cause of death as cerebral edema caused by a reaction to a painkiller Lee had taken for a headache. An ordinary end for an extraordinary man?

Enter The Dragon eventually grossed over $200m worldwide – a record budget/box-office ratio and, despite frequent droopy dialogue and cheesiness, still stands as the undisputed classic of the martial arts movie genre. It confirmed Lee as a worldwide icon – even cleaning up in notoriously Chinese-hostile Japan – and, had he lived, it would surely have fortified his unprecedented (and unfollowed) status as a top-of-the-bill movie opener in both East and West.

chapter five

"*game of death*"

GAME OF DEATH (1978; Hong Kong release title: **Si wang you ju**)
85 minutes (original length: 110 minutes)
CAST: Bruce Lee (Billy Lo); Gig Young (Jim Marshall); Dean Jagger (Dr. Land); Hugh O'Brian (Steiner); Colleen Camp (Ann Morris); Robert Wall (Carl Miller); Mel Novak (Stick); Kareem Abdul-Jabbar (Hakim); Chuck Norris (Fighter); Danny Inosanto (Pasqual); Billy McGill (John); Hung Kim Po (Lo Chen); Roy Chaio (Henry Lo); Tony Leung (David); Jim James (Surgeon); Russell Cawthorne (Doctor); Kim Tai Jong (Billie Lo).
CREDITS: Producer: Raymond Chow; Director: Robert Clouse; Screenplay: Jan Spears; Cinematography: Godfrey A. Godar; Editor: Alan Pattillo; Music: John Barry; Special Effects: Far East Effects; Make-up: Graham Freeborn; Martial Arts Director: Hung Kim Po.

"This electrically charged film contains the most spectacular footage of the Chinese-American superstar ever filmed. It is, we feel, a fitting memorial to Bruce Lee."

—Robert Clouse, promotional material for **Game Of Death**.

Bruce Lee died on July 20th, 1973 at the age of 32. To his friends, relatives and admirers, it was an abrupt and numbing end for a man whose dedication to physical and mental discipline lent him an aura of invincibility. To Raymond Chow and Golden Harvest, it was a huge commercial inconvenience. Off the back of his most accessible film, **Enter The Dragon**, Lee's western box-office was finally booming. **Enter The Dragon** grossed a then-massive $3m in its first seven weeks in the US, before a sell-out five-week run in London and Europe. In Hong Kong, Chow responded by raising his cinema admission prices by more than 50 percent, and, once the grisly hysteria of the show-funeral had subsided, the cash-in tills began chinging in earnest.

The exploitation machine rolled on [see next chapter], and then, in 1977, Raymond Chow got his hands on twenty-eight minutes of fight footage shot by Lee as part of an intended future project called **Game Of Death**. The film had been postponed to make way for **Enter The Dragon**, but the unique footage – of which only around fifteen minutes were claimed to be usable – was enough to set the dollar-signs flashing in Chow's eyes.

"kung-fu is like water. You cannot punch it and hurt it, you cannot grasp hold of it. Every kung-fu man is trying to do that – be flexible. To adapt to the opponent."

—Bruce Lee

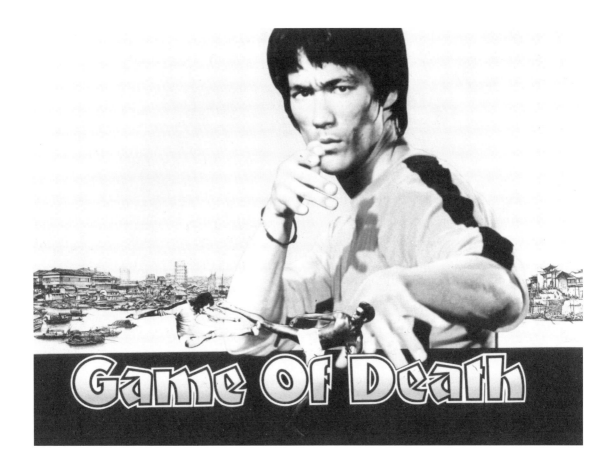

Game Of Death

Lee's original inspiration for **Game Of Death** came on a location-scouting visit to India. Standing on the border with Nepal, he was impressed with the vast, pagoda-like temples and conceived a story involving a noble martial artist who battles to recover a treasured cultural artefact stolen by a criminal gang and stashed on the top floor of a similar building. Each floor of the pagoda is defended by a master of a different martial art: karate, kung-fu, *escrima*, *hapkido*... all leading to a final confrontation on the top floor with a physical giant who fights in less classical, unpredictable style (in this case, played by seven foot-plus basketball star Kareem Abdul Jabbar). Lee saw the film as a chance to target a wide audience with his philosophy on the need for martial arts to evolve away from rigid, classical tradition. He wrote an impression of an opening scene:

"As the film opens, we see a wide expanse of snow. Then, the camera closes in on a clump of trees while the sounds of a strong gale fill the screen. There is a huge tree in the centre of the screen, covered in thick snow. Suddenly there is a loud snap and a branch of the tree falls to the ground. It cannot yield to the force of the snow, so it breaks. Then, the camera moves to a willow tree which is bending with the wind. Because it adapts to the environment, it survives. What I want to say is that a man has to be flexible and adaptable, otherwise he will be destroyed."

Almost immediately after finishing European filming on **Way Of The Dragon**, Lee went back to Hong Kong and gathered together Kareem Abdul-Jabbar, *escrima* master Dan Inosanto and seventh-degree *hapkido* black belt Chi Hon Joi. The fight scenes were filmed in a week, before Lee was abruptly called over to the US to finalise a deal with Warner Bros. for his first Hollywood movie. As **Enter The Dragon** went into production, **Game Of Death** was suspended.

Following Lee's death, the footage passed over to his estate, via wife Linda and was eventually bought by Chow for $200,000. The initial plan was to bring in **Enter The Dragon** director Robert Clouse to tie the footage together with a few basic bridging sequences and opt for a shorter running time. But when it became clear that only around half of the twenty-eight minute fight-scene footage was usable, Chow began a search for two actors who could double as Bruce Lee — aided, depressingly, by Linda. Following auditions at Universal Studios, the actors were selected and Chow hired screenwriter Jan Spears to mould a story onto the skeleton. The film was scheduled for release in 1978 and budgeted at $4.5m.

Spears ditched the original premise and spun off on a popular conspiracy theory of the time — that Lee had faked his own death. The Lee character is Billy Lo, a Hong Kong-based martial arts movie star being hounded by an underworld organisation known, laughably, as The Syndicate. The film begins with Billy filming the closing scene of his latest movie (actually, the Chuck Norris fight scene from the end of **Way Of The Dragon** — which also enabled Chow to tack Norris' name onto the bill). In his dressing room, Billy is menaced by Syndicate enforcer Hugh O'Brian, who warns him to cough up the protection money. Billy refuses and punches O'Brian, who, in true B-movie villain style, warns him that he's made "a very big mistake". The most painful image here comes when we finally get a shot of Billy's face — in the mirror as O'Brian stands behind. The moving body below is real, but the face is a stationary, expressionless cardboard cut-out of Lee. It's a suitable indication of the extended hack exploitation job to follow.

Billy chats with Ann, his famous singer girlfriend, who is also being pestered by The Syndicate. We meet the main bad guys, bossed by Dr Land (Dean Jagger) who, inevitably, has a fetish for Japanese fighting fish. There's talk of the weather and, eventually, of Billy's reluctance to pay his protection. Action point: "squeeze" a little harder.

At night, in an extremely dark car, with Billy wearing large sunglasses, Ann and Billy talk about their Syndicate troubles. Ann issues a stern warning: "I've heard some pretty ugly things about those guys. Pretty ugly." On cue, the couple are attacked by a gang of affiliated motorcycle riders. Billy sees most of them off (with, it seems, overdubbed Bruce Lee yelps) but is eventually waylaid by a chair to the back. "Another message" is delivered.

In an extremely dark restaurant, with Billy wearing large sunglasses again, Ann and Billy talk to a journalist friend Jim (Gig Young) who offers some confusing advice: the Syndicate are ruthless and extremely dangerous, but it's important not to give in. Billy offers what is clearly Spears' idea of Bruce Lee aphorism ("It is better to die a broken piece of jade than to live a life of clay"). Billy visits his uncle who tells him he must fight the extortion attempts at all costs. The bad guys turn up, engage in some strikingly inelegant fisticuffs with Billy and deliver their final message. Later, at Syndicate HQ, they agree to "close the book" on him.

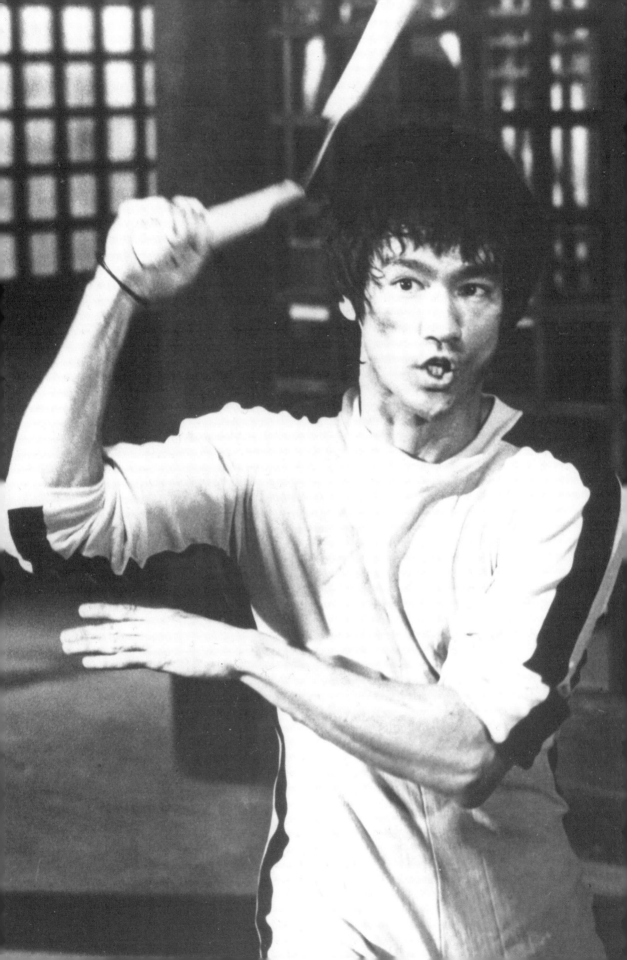

Ann and Billy meet at the ferry – watched by token Mysterious Man Behind Newspaper. They agree to separate temporarily while Billy sorts everything out. On Billy's film set, a Syndicate member, Stick (Mel Novak) loads a real bullet into a prop gun (eerie shades of 1994's **The Crow**, on whose set Lee's son Brandon was killed by a loaded prop pistol) and, conveniently, shoots Billy in the face. Most of the old footage is of Lee's final leap of defiance from the end of **Fist Of Fury**. Thinking Billy dead for certain, Stick takes off (with a comedy recognition jostle from Ann).

Later, Jim takes Billy to… a plastic surgeon, who agrees to mend/alter his appearance and help in issuing a fake death certificate and new identity. Ludicrously, Ann doesn't know Billy has survived and Jim insists she be kept in the dark about his rebirth. Chow/Clouse then deliver the ethical equivalent of necrophilia, in presenting Billy's fake funeral with actual footage of Lee's Hong Kong ceremony (complete with open casket shots). All delightfully intercut with Billy's plastic surgery.

The Syndicate visit Ann in her sanitarium – to a predictably frosty reception. Ann recognises Stick from the night of the shooting. She calls Jim and tells him she knows who killed Billy and that, ominously, "the police aren't the answer". Back at the secret plastic surgery hospital, Billy (face completely obscured with bandages) carefully fine-tunes his radical new look which involves wearing a moustache and beard. And large sunglasses.

The slightly modified Billy follows the Syndicate members to a meeting with some Chinese guests who hand over a kickback relating to an upcoming martial arts tournament featuring the boss' bodyguard Carl (Bob Wall). Billy attacks Dr Land and, following a brief, reasonably well choreographed scuffle, escapes with Carl in futile pursuit.

At the tournament, Ann approaches Dr Land and moves to pull a pistol from her handbag. Billy (now disguised in an old man face mask) discourages her. But when she turns around… he's gone.

Carl wins his fight and, locked in his dressing room, is beaten to death by Billy (plenty of ill-spliced shots from **Way Of The Dragon**). Here, the fighting is at least watchable, with the double doing an intrepid impersonation of Lee's physical trademarks (the thumb-wipe of the nose, the wound-up death blow). The suspicious Syndicate boys dig up Billy's casket and discover that the body is false.

Ann and Billy meet (in the darkest place so far, with Billy's features completely obscured behind an iron gate). Billy urges Ann to leave town while he finishes the job, but the Syndicate motorcycle boys kidnap Ann and pass a message to Jim that she'll be spared only if Billy turns up at an out-of-town warehouse. Obviously, the meeting is a trap and, in a reasonable action set-piece, Billy fights the motorcycle riders (but not before blending in by wearing a large helmet with an opaque visor). Stick confesses Ann's actual location – the Red Pepper restaurant – and Billy arrives, ready to do battle with the boss's best men.

What happens next depends upon in which country you're watching the film. We cut to Lee's original footage of his face-offs with increasingly deadly martial artists. First up is Inosanto, dressed in traditional Muslim costume with red headband and armed with the *escrima* exponent's double sticks. Lee responds with the Chinese *bako* – a thin, flexible bamboo stick. Once Inosanto is disarmed, the fight switches to a vicious and hectic death-duel with *nunchaka* – a weapon which Inosanto had introduced to Lee in real life.

On the next floor, *hapkido* master Chi Hon Joi is classical and effective, until Lee defeats him by adapting to his own style. The following sequence with Kareem Abdul Jabbar is masterful: the dwarfed Lee snapping away like a terrier to a rotweiler, slowly winning ground before delivering a neck-breaking *coup de grâce*. This original footage used lasts for about 10 minutes only.

And then, the lights are dimmed down to squint level for a final, ungainly slug-out between the Lee "double" and Hugh O'Brian, armed with his stick and retractable blade. O'Brian waddles around, trading swipes like a tipsy hooligan and is eventually despatched to clear the way for the spectacularly unsatisfying climax. Billy heads up to the top floor and discovers Dr Land at his desk, having apparently slit his own wrists. But the figure is exposed as a wax replica and Billy chases the real Syndicate boss out onto the roof. Without a blow being exchanged, Dr Land slides pathetically to the edge and is switched with a floppy rag-doll version which crashes down through the neon to the street below. The end credits – a montage of fight scenes from Lee's previous films – offer a half-hearted attempt at a "tribute" which feels more like the result of an editor's guilty conscience than anything approaching respect from Clouse or Chow.

"Empty heads have long tongues."
——Bruce Lee

Game Of Death premiered at the Paramount Theatre in Hollywood Boulevard on June 7th, 1979. Widely advertised as an all-new Bruce Lee film, no mention was made of the doubles. Well over a thousand fans attended, many dressed in martial arts uniforms and carrying the banner of their schools. Lee's son, Brandon, introduced a thirty-foot long display featuring costumes and weapons from his father's films. Mayor Tom Bradley proclaimed the day to be "Bruce Lee Day". Understandably, as the film began, the euphoria soon dried up.

Amazingly, most of the actors involved with the film seem blind to its tackiness. Hugh O'Brian (surely one of few actors to experience the joy of conversing with a cardboard cut-out of a head) plugs the conspiracy line: "About a third of the film was done before Bruce died. There is a good question in some people's minds as to whether or not Bruce did die." Gig Young seems only vaguely aware of the background details: "I was actually very thrilled to be in something which I consider in many ways, not historical, but to capture the footage that Bruce Lee had already shot when he unfortunately died." Only Bob Wall concedes any sense of regret: "**Game Of Death** was hindered by having the man I consider to be one of the worst action directors of all time. I told Raymond Chow that Clouse would ruin it, because this time he didn't have Bruce to save him. Under the circumstances, I think we did the best possible job."

In his own strangled account of Lee's life, Robert Clouse further blackens his reputation by attempting to sidestep responsibility altogether: "The final cut, with an attempt to use two lookalikes, was disappointing at best. Yet the film was quite successful, as was almost anything about Bruce Lee, no matter how tasteless or fraudulent."

Game Of Death is a tasteless and fraudulent piece of work in anyone's language. Aside from the ethical issues, Clouse's direction is sloppy and ill-focused (he seems to have trouble finding the centre of action in the crucial fight scenes, leading to numerous off-frame mishaps) and the dialogue is dismal. O'Brian and Jagger saunter listlessly through the whole sub-TV movie atmosphere and the Bruce Lee doubles are little more than ghostly impressions of an individual who easily acts them off the screen through his pop-up stock footage appearances alone. And, when the true Lee sequence finally arrives, the gulf of class is thrown into even sharper relief.

Generally, Lee's films may not be masterpieces, but they do showcase an expert martial artist with a steadily developing poise and charisma as a screen actor. **Enter The Dragon** was the start of a new phase of autonomy, but who knows what he might have achieved had he been given the opportunity to channel his abilities with the right screenwriters, actors and directors. **Game Of Death** is nothing more than an affront to his memory, and determined Lee collectors should at least take care to keep their copy permanently wound on to the beginning of the pagoda sequence, and to switch off after the Abdul Jabbar fight.

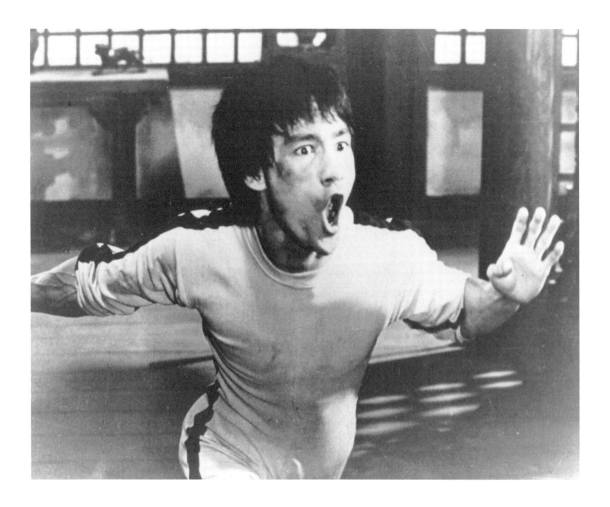

POSTSCRIPT

Finally, in 2000, the complete **Game Of Death** footage shot and edited by Bruce Lee between August and October 1972 was made available. The footage, which amounts to about 34 minutes, was included in **Bruce Lee: A Warrior's Journey**, an excellent documentary directed by John Little which also utilizes behind-the-scenes footage plus interviews with those who knew and worked with Lee to paint a complex picture of the man, his movies and his martial arts philosophy. In its latter half, Little's film focuses in on Lee's original script (working title: **Song Of The Night**) and shooting notes for **Game Of Death**, showing a completely different film from the existing "version". This was to be Lee's crowning glory, the film that would encapsulate and crystallize his martial arts philosophies once and for all time. The completed footage that follows, showing Lee in his fighting prime, demonstrates how "no style" can, by fluidly adapting to other fixed styles, be triumphant. As such, it is almost certainly Lee's best work on film and a fitting epitaph for this unique martial artist and human being.

THE BIG BOSS

Starring: BRUCE LEE
MARIA YI
JAMES TIEN
Directed by: LO WEI

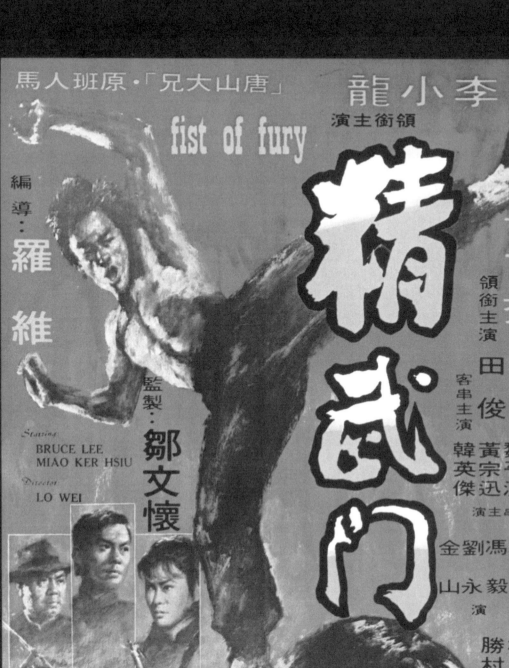

馬人班原・「兄大山唐」　　　　龍小李

fist of fury　　演主銜領

編導:羅維

Starring
BRUCE LEE
MIAO KER HSIU

Director
LO WEI

監製:鄒文懷

精武門

苗可秀

領銜主演

田俊

客串主演

韓英傑

衣依田豐

魏平澳

黃宗迅

演主串客

馮李羅
劉昆維
金永毅主
山演

R. BAKER

橋本力　李英琪

勝村淳　合演

陳福慶

片影佳最 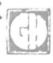 獻貢禾嘉

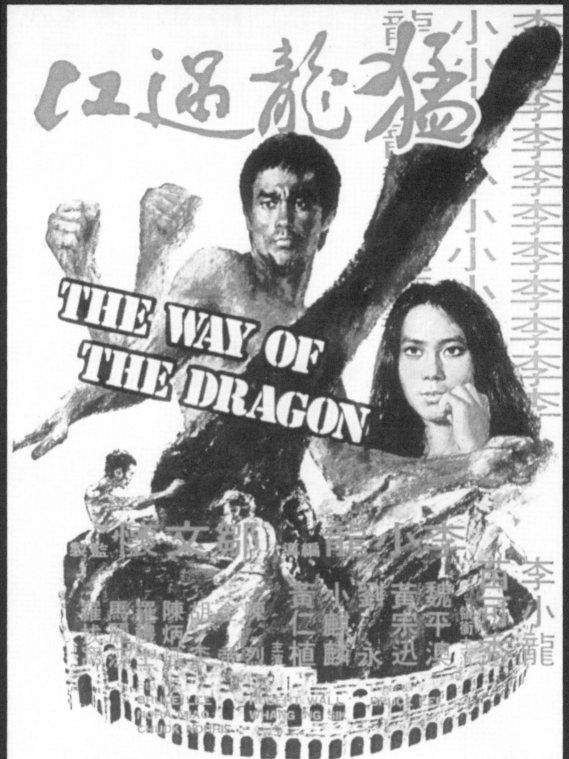

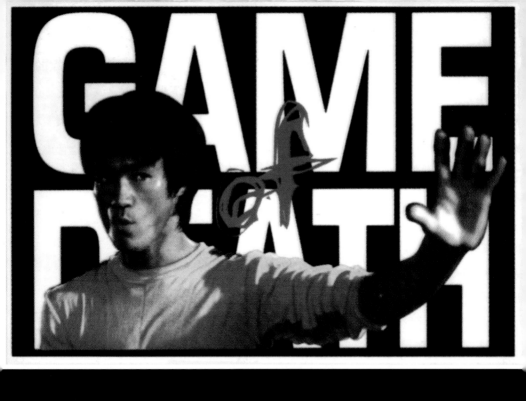

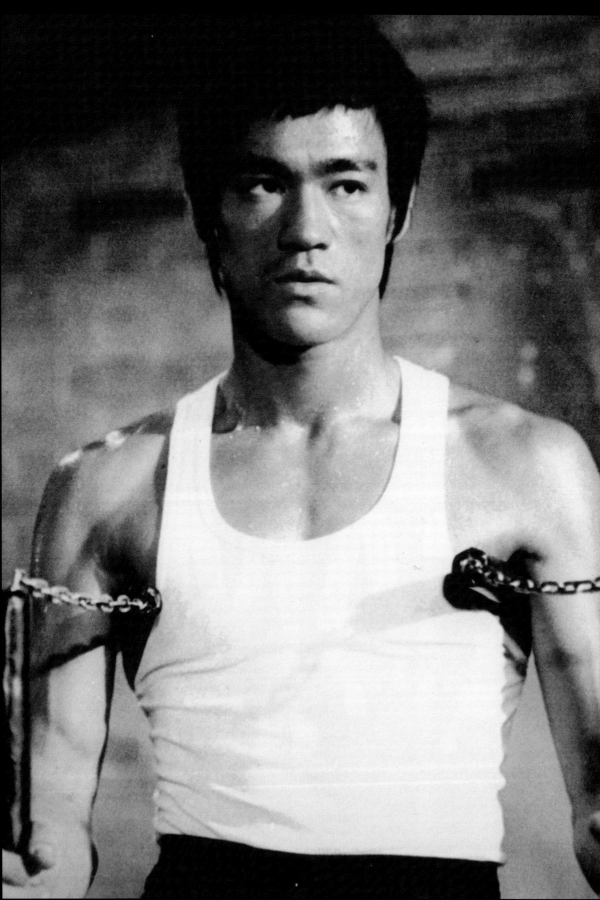

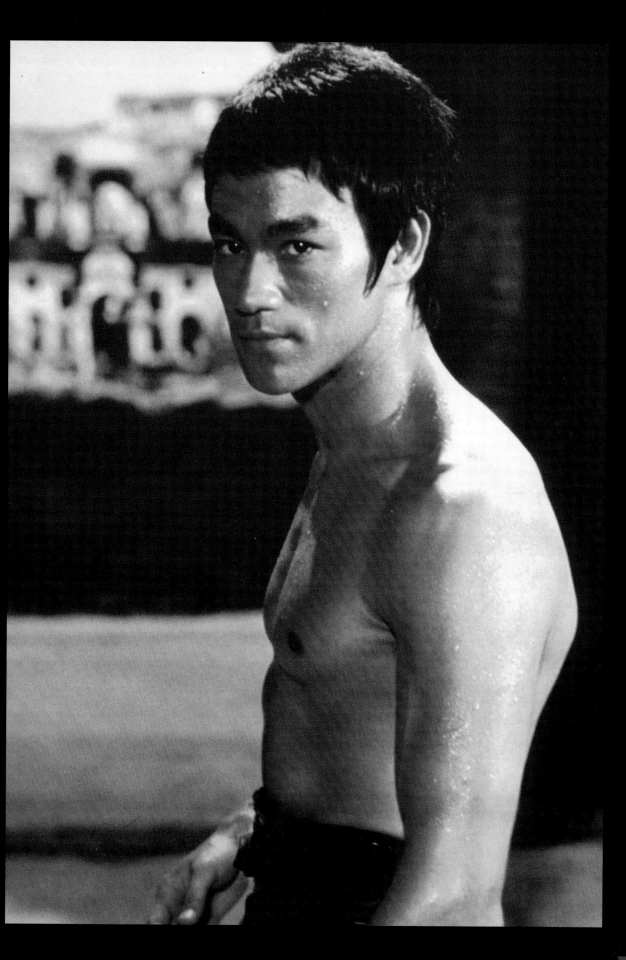

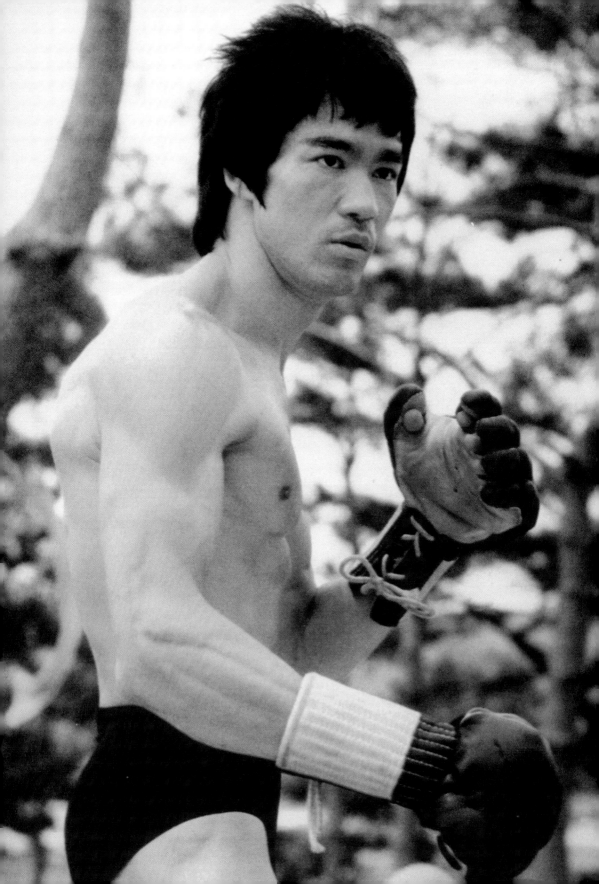

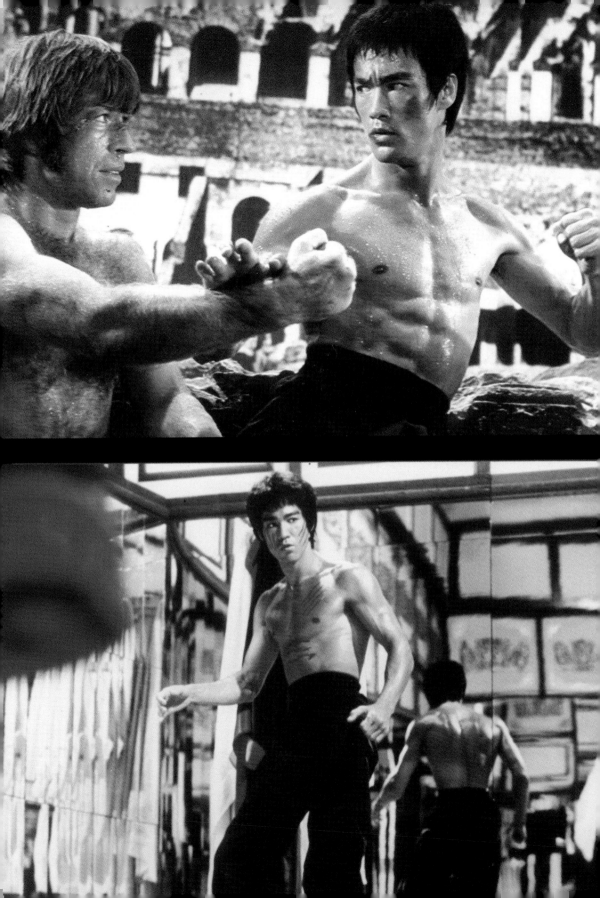

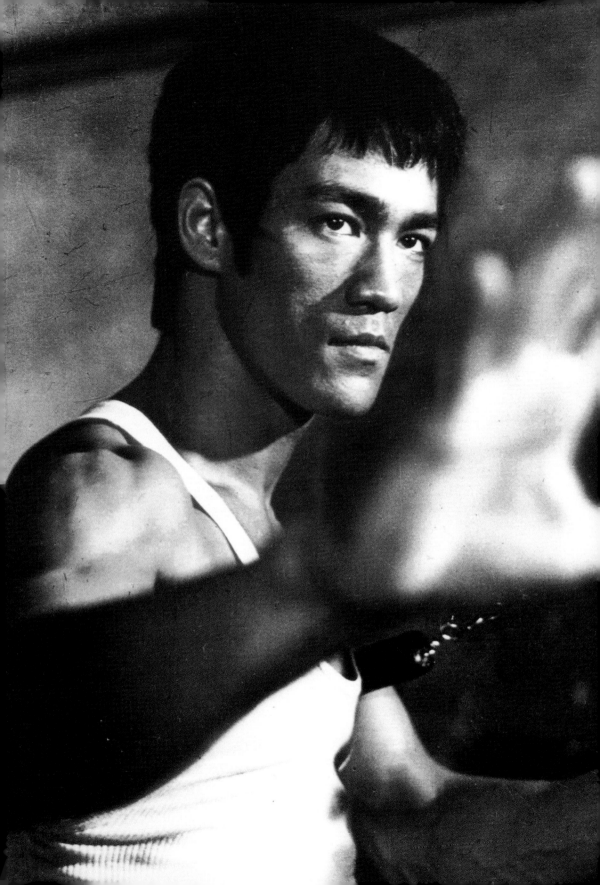

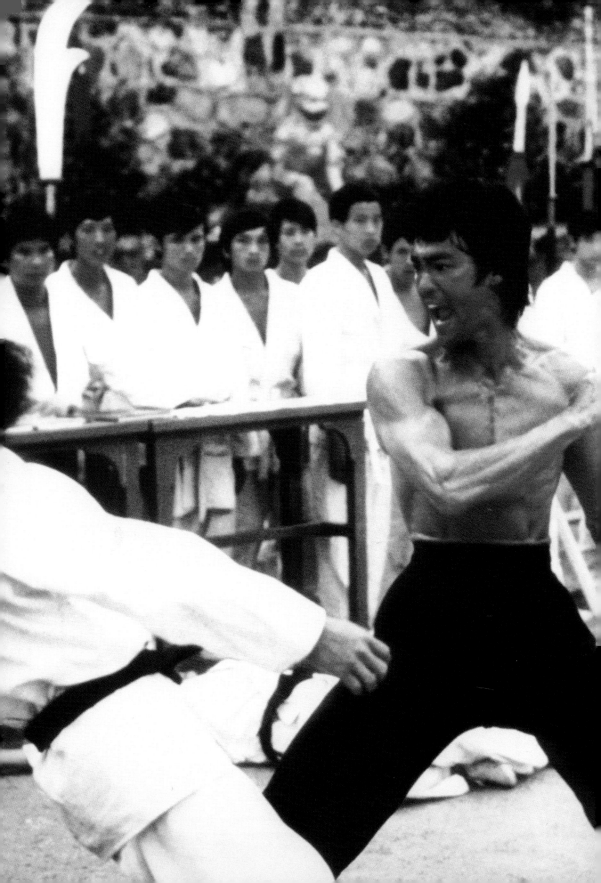

ALL NEW ———————— ALL TRUE

CINEMA SHARES DISTRIBUTION CORP. Presents

BRUCE LI
STARRING IN

BRUCE LEE
THE MAN
THE MYTH

So much like him you'll swear ★ **BRUCE LEE LIVES!**

CSID presents BRUCE LI AS BRUCE LEE: THE MAN/THE MYTH • Based on The Life and Times of Bruce Lee • Produced by Eternal Film Company
Directed by Ng See Yuen • With LINDA HERST • DONNIE WILLIAM • DAVID CHOW • MARIO VIEDIANO • ROBERTO CIAPPI
Prints by Capitol Film Laboratories • EASTMANCOLOR • CINEMASCOPE • [PG] PARENTAL GUIDANCE SUGGESTED
Released by CSI Cinema Shares International Distribution Corporation

BRUCE LEE

Bruce Lee challenges the underworld to a "Game of Death."

GAME OF DEATH

GOLDEN HARVEST PRESENTS
A RAYMOND CHOW PRODUCTION
BRUCE LEE in "GAME OF DEATH"

GIG YOUNG DEAN JAGGER COLLEEN CAMP and HUGH O'BRIAN Featuring CHUCK NORRIS MEL NOVAK
ROY CHIAO DANNY INOSANTO BOB WALL Special Guest Star KAREEM ABDUL JABBAR AS "HAKIM"

Director of Photography GODFREY A. GODAR Film Editor ALAN PATTILLO Music Composed and Conducted by JOHN BARRY Associate Producer ANDRE MORGAN
Written by JAN SPEARS Produced by RAYMOND CHOW Directed by ROBERT CLOUSE Filmed in Panavision® Color by Technicolor®

chapter 6
biopix & brucesploitation

Bruce Lee's sudden death left a huge void in the Hong Kong industry. Film-makers desperate to capitalize on the Lee name were quick to seize on biopix as a way to give longevity to his box-office appeal. Thus began a succession of biographical films – most highly fictionalized – about his short life and career. Golden Harvest were first on the bandwagon with **The Life And Legend Of Bruce Lee** (1973), which starts with lengthy footage from Lee's funeral before examining his house and possessions and then switching to Lee himself talking about his films and in training. Easily dismissed as a swift cash-in, this movie was actually just the start of a veritable *tsunami* of documentaries, cut-and-paste biographs and ersatz kung-fu features which rolled on into the 1980s and may now be given the generic description "Brucesploitation".

A US production company – this time 20th Century Fox – was also quick to cash in, stitching together 4 episodes of the *Green Hornet* TV series – "The Hunters And The Hunted", "The Praying Mantis" and "Invasion From Outer Space" 1 & 2 – into a feature film entitled **Bruce Lee: The Green Hornet** (1974). The only benefit of this film – which was shamelessly promoted with unrelated Bruce Lee stills and garish newspaper ads insisting that it was a "new" Lee movie – to fans was the inclusion of Lee's original screen test for the role of Kato. Fox repeated this trick in 1976, producing another compendium film, **Fury Of The Dragon** (containing another four episodes: "The Ray Is For Killing", "The Secret Of Sally Bell", "Bad Bet On A 459", and "Trouble For Prince Charming").

Bruce Lee And I

Back in Hong Kong, The Shaw Brothers got their posthumous money's worth with **Bruce Lee And I** (1975), which starred actress Betty Ting Pei in a tacky dramatized account of her relationship with Lee. Ting Pei goes topless and, naturally, is shown to be guilt-free in the death of the kung-fu superstar.

In 1976, **Bruce Lee: The True Story** (US title **Bruce Lee: The Man, The Myth**) was the first attempt at a straight biopic, starring Lee imposter Ho Chung Tao (aka Bruce Li) and, worryingly, one of Lee's closest friends, Unicorn. It's a highly fictionalised account, at one point featuring Lee jacking himself into a ludicrous device in an attempt to optimise his physical powers.

Bruce Lee: The Legend (1977) was Golden Harvest's "official tribute" to Lee, and covered his whole life with plenty of interviews, movie clips and "real life" footage alike, right up to and including Lee's funeral. It remains one of the best Bruce Lee documentaries.

After that came a steady flow of other biopix from various sources, but it was not until 1993, and Rob Cohen's **Dragon: The Bruce Lee Story**, that a big-budget, officially-sanctioned dramatized biopic of Bruce Lee would finally emerge. Based on the book *Bruce Lee: The Man Only I Knew* by Linda Lee, **Dragon** stars Jason Scott Lee (no relation; Bruce's son, Brandon Lee, had refused to play his father) in the title role. Unfortunately, the film turned out to be a highly fictionalized, Hollywood-style version of Lee's life. As well as some highly dubious "psychological" effects – Lee's notorious anger visualized by the appearance of demons dressed in battle armour – the film over-compensated for Scott Lee's lack of martial arts prowess by having him (or a double) perform frenetic acrobatics quite unlike the real Lee's style of *jeet kune do*. With cameos by many people who had actually worked with Bruce, **Dragon** turned out to be a fairly entertaining but ultimately unenlightening project.

Other posthumous spin-off films have included: **The Last Days Of Bruce Lee** (1973); **Death Of Bruce Lee** (1975); **Bruce Lee – His Last Revenge** (1978); **Spirits Of Bruce Lee** (1979); **Fist Of Fear, Touch Of Death** (1980); **Bruce Lee Fights** (1983); **Bruce Lee And Kung-Fu Mania** (1992); **The Life Of Bruce Lee** (1993); **Bruce Lee – Best Of The Best** (1993); **Bruce Lee: Curse Of The Dragon** (1993); **Bruce Lee: Martial Arts Master** (1993); **Bruce Lee: The Lost Interview** (1994); **Bruce Lee: Jeet Kune Do** (1995); **Death By Misadventure** (1995); **Bruce Lee: The Immortal Dragon** (1996); **Bruce Lee In His Own Words** (1998); **Bruce Lee: The Path Of The**

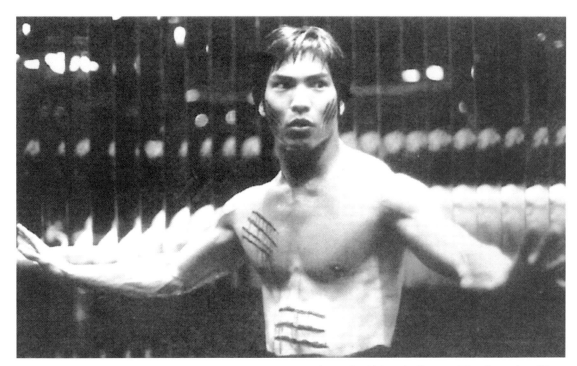

Jason Scott Lee in **Dragon: The Bruce Lee Story**

Dragon (1999); **Bruce Lee: The Intercepting Fist** (2000); and **Bruce Lee: The Legend Lives On** (2002). As the new millennium and new technology progressed, Korean film-maker Chul Shin even talked of a new CGI Bruce Lee movie, **Dragon Warrior** – but nothing has materialised as yet.

The second type of film that sought to capitalize on Bruce Lee's posthumous fame comprised a veritable sub-industry of "Bruce Lee exploitation" that lasted into the 1980s, employing both Lee look-alikes and film titles featuring Lee's name to keep the lucrative wagon rolling in a seemingly endless succession of low-budget features. The main Bruce Lee impersonators were Bruce Li, Bruce Le, and Dragon Lee, although others such as Bruce Liang (**Bruce Lee, D-Day At Macao** [1973]) and Bruce Lea (**Bruce Lee Fights Back From The Grave** [1976]) also surfaced. Bruce Liang stars in one of the most outrageous Brucesploitation movies, **Dragon Lives Again** (aka **Deadly Hands Of Kung Fu**, 1976), in which he plays Bruce Lee in Hell! This is a film which has to be seen to be believed – suffice to say that in Hell, Bruce encounters not only numerous naked women and an army of killer mummies, but a cast of characters that includes Dracula, Popeye, Clint Eastwood's Man With No Name, James Bond, the Godfather, the Exorcist, Emanuelle, and Kwai Chang Caine from the TV series *kung-fu*. This is sadly indicative of the tone, quality and budget of the Brucesploitation genre as a whole.

Bruce Li – real name Ho Chung Tao – was not even an actor when his vague resemblance to Bruce Lee was noticed and he was plucked from his job as a PE teacher in Taiwan. After crash courses in kung-fu and acting he was plunged into his new life as Bruce Li (*aka* the Tiger). Li's movies – which are

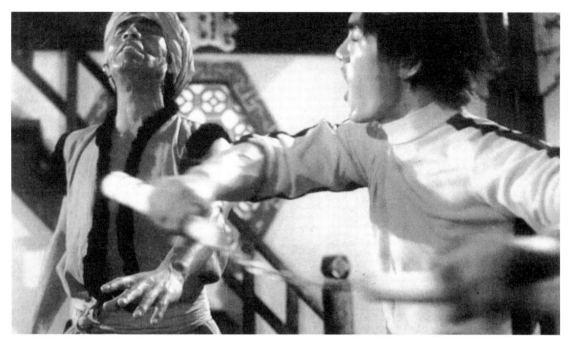

Bruce Li in **New Game Of Death**

generally ultra-low budget and hung around ludicrous plot-lines – include: **Bruce Lee, Super Dragon** (1974); **Last Game Of Death** (1975); **Bruce Lee Vs Supermen** (1975); **Fist Of Fury 2** (1975); **Bruce Lee: A Dragon Story** (1976); **Bruce Lee In New Guinea** (1976); **Bruce Lee's Big Secret** (1976); **Exit The Dragon, Enter The Tiger** (1976); **Enter The Panther** (1976); **Bruce Lee's Iron Finger** (1977); **Bruce Lee The Invincible** (1977); **Bruce Lee Vs Iron Hand** (1977); **Fists Of Bruce Lee** (1978); **Image Of Bruce Lee** (1978); **Fist Of Fury 3** (1978); **Bruce Lee's Magnum Fist** (1978); **Blind Fist Of Bruce** (1979); **Master Of Jeet Kune Do** (1980); **New Game Of Death** (1981); and **The Young Bruce Lee** (1982). Bruce Li retired from the film industry in 1985, after more than a decade as an impersonator.

Bruce Le – real name Huang Kin Lung – starred in **Return Of Fists Of Fury** (1976); **Big Boss 2** (1976); **Return Of Bruce** (1977); **Bruce Vs Black Dragon** (1977); **The Clones Of Bruce Lee** (1977, also featuring Dragon Lee, Bruce Lai and Bruce Thai); **Bruce Lee's Greatest Revenge** (1978); **The Treasure Of Bruce Lee** (1980); **Legend Of Bruce Lee** (1980); **Bruce's Deadly Fingers** (1980); **Bruce, King Of Kung Fu** (1980); **Bruce Vs Bill** (1981); **True Game Of Death** (1981);and **Ninja Vs Bruce Lee** (1982), amongst others.

The Soviet-Korean Dragon Lee – real name Vyachaslev Yaksysnyi and sometimes billed as Bruce Lei – first showed up in **The Real Bruce Lee** (1973), and in later films such as **Enter The Deadly Dragon** (1978), **Dragon Fights Again** (aka **Bruce Lee Fights Again**, 1978), **Dragon, The Young Master** (1978) **The Dragon On Fire** (1979, *aka* **True Game Of Death**, also featuring Bruce Lea), and **Bruce Lee's Ways Of Kung Fu** (1982).

This avalanche of trash finally started to subside as the 1980s progressed, but it would not be until 2000 and the release of **Bruce Lee: A Warrior's Journey** that a truly worthwhile and valid addition to Bruce Lee's cinematic legend and memory would appear. Assembled by John Little, this was in itself one of the better Lee documentaries – but the real coup of this movie was to show, finally, the complete footage shot and edited by Bruce Lee for **Game Of Death**. In presenting this cinematic Holy Grail to Lee's millions of fans, **A Warrior's Journey** makes the ultimate, and hopefully closing statement about Bruce Lee – by letting the man's actions and art finally speak for themselves.

THE MYSTERY. THE LIFE. THE LOVE. THE LEGEND.

DRAGON

THE BRUCE LEE STORY

UNIVERSAL PICTURES PRESENTS A RAFFAELLA DE LAURENTIIS PRODUCTION A ROB COHEN FILM JASON SCOTT LEE · LAUREN HOLLY "DRAGON : THE BRUCE LEE STORY" NANCY KWAN AND ROBERT WAGNER MUSIC BY RANDY EDELMAN CO-PRODUCER RICK NATHANSON DIRECTOR OF PHOTOGRAPHY DAVID EGGBY, A.C.S. EXECUTIVE PRODUCER DAN YORK BASED ON THE BOOK "BRUCE LEE: THE MAN ONLY I KNEW" BY LINDA LEE CADWELL SCREENPLAY BY EDWARD KHMARA AND JOHN RAFFO AND ROB COHEN PRODUCED BY RAFFAELLA DE LAURENTIIS

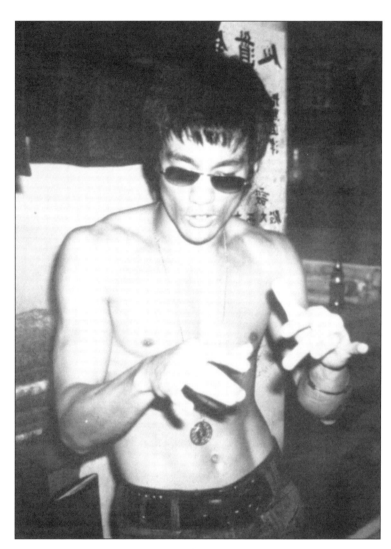

Bruce Lee (1940-1973)

index of films

Page numbers in bold indicate an illustration